IMAGES
of America

MOUNT PLEASANT

George Waterbury -
God Bless America

Claudine Waterbury
Jaws in History

Bart R

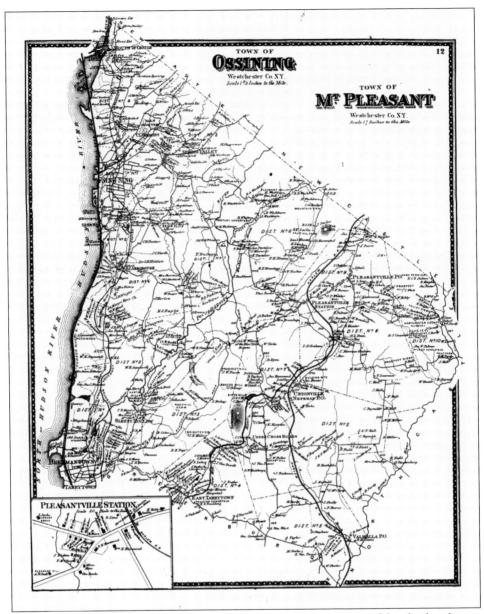

This 1867 map shows the town of Mount Pleasant. It was incorporated by the legislature of New York State on March 7, 1788, but its territorial limits were abridged on May 2, 1845, when Ossining was separated into an individual township.

On the cover: This 1890 photograph was taken at the old Tompkins Avenue freight yard in Pleasantville. The house in the background is on Choate Lane. The ridgeline is Pace University property. The steam-powered locomotive is a Forney "Little Giant" built exclusively for short-haul freight. A typical cabin included the engineer and young firemen who fed coal into the furnace. The Little Giant was known for the generation of soot, which is evident on the happy faces of the railroad men. There is some speculation that this photograph was taken on payday. (Courtesy of the Mount Pleasant Historical Society.)

IMAGES
of America

MOUNT PLEASANT

George Waterbury, Claudine Waterbury,
and Bert Ruiz

ARCADIA
PUBLISHING

Published by Arcadia Publishing
Charleston SC, Chicago IL, Portsmouth NH, San Francisco CA

Printed in the United States of America

Library of Congress Catalog Card Number: 2008935278

For all general information contact Arcadia Publishing at:
Telephone 843-853-2070
Fax 843-853-0044
E-mail sales@arcadiapublishing.com
For customer service and orders:
Toll-Free 1-888-313-2665

Visit us on the Internet at www.arcadiapublishing.com

To the people of Mount Pleasant

CONTENTS

ACKNOWLEDGMENTS

The acknowledgments page of every book is a sticky thicket. There inevitably is always someone overlooked. However, there are clearly those individuals who stand above all others. On that note, there is no doubt that this book would not have been possible without the steadfast editorial assistance of John Crandall and the generous gifting of his vast collection to the Mount Pleasant Historical Society. Minister Jim Brown and Marie Labue must also be commended for their skilled contributions on the final edit.

The Mount Pleasant Historical Society provided the majority of the photographs for this text. To this end, key collections in the archives include those of Del Pietschker, Will Hurley, Kenneth Soltez, and Otto Armisto. The authors are also especially grateful to the families who shared private collections. They include Dianne Ripley, Grace Rubino Baer, Anne Moroney, Louise Perez, Dick Devine, and Sam Arcidiacono. Recognition must also be given to Carsten Johnson, historian for the Village of Pleasantville; to Katherine Hite, Trish Foy, and Patrick Raftery of the Westchester County Historical Society; and to Barbara and Lewis Massi of the North Castle Historical Society.

Certain individuals provided logistical support or pitched in on certain segments of the book and must be congratulated. They include town supervisor Bob Meehan, Paul Bourquin, Jean Carpenter, David Nelson, Henry Stroobants, Dr. Robert Valentine, and Bob Angiello, owner of Thornwood Office Essentials. There must also be a special thanks to Clare Ruiz, Bert's wife, and their four sons, Bert Jr., Justin, Jack, and Jamie, for the many evenings and weekends Bert Ruiz Sr. spent away from home. Finally, the authors want to express sincere gratitude to Rebekah Collinsworth and Heather Fernald, our editors at Arcadia Publishing, for their prompt and professional attention.

INTRODUCTION

The production of this book was a labor of love. George Waterbury has been the preeminent authority on the history of Mount Pleasant for the past decade. His wife Claudine has always been heavily involved in George's work, and collectively they have been the heart and soul of the Mount Pleasant Historical Society. On that note, George and Claudine were determined to publish a book with Arcadia Publishing and enlisted lead trustee Bert Ruiz, an accomplished author, to take editorial control of the book and to write the narrative. To this end, this book was completed without one argument, schism, or raised voice. It truly was a labor of love for three close friends and dedicated historians.

One of the original objectives of the book was to finally put to rest all the speculation about how Mount Pleasant was named. There are no official records in the official legislative archives of the State of New York as to the origin of Mount Pleasant. Most local historians attribute the naming of Mount Pleasant to either Italian explorer Giovanni da Verrazano, English explorer Henry Hudson, or James Beekman, the great-grandson of Dutch settlers to New Amsterdam. Some British historians attribute the name Mount Pleasant to the Royal Mail Mount Pleasant Post Office in London. However, records indicate it was built on the site of the old Cold Bath Prison in 1790 and the town of Mount Pleasant in New York was incorporated in 1788.

Giovanni da Verrazano was the first European explorer to enter New York Bay. He did so in 1524. Verrazano was employed in the naval service of Francis I of France and was known to keep a good journal. His notes were the first post-Columbian description of the North Atlantic Coast. While anchored in New York Bay, Verrazano described, "We found a very pleasant situation amongst some steep hills" along the coastline. Henry Hudson discovered the Hudson River in 1609. He was employed by the Dutch East India Company and did not speak Dutch. Hudson more than likely dictated his notes to a crew member who maintained a Dutch journal. Hudson described the land at the mouth of the Pocantico "as pleasant a land as one need tread upon." There has also been considerable speculation that the Dutch crew members were natives of a very flat nation and often called hills mountains. Hence, some historians think that Hudson's Dutch crew named Mount Pleasant.

Finally, the Beekman family was one of the founding families of New York. The Beekman name still lives on in New York City landmarks such as Beekman Place and the Beekman Theatre. In 1771, the family acquired a London-made carriage that was the pride of the family. The family coach can be found at the historical society in New York City where it was showcased as "an exceedingly rare artifact of genteel life in early New York." Just around this time, while James Beekman was at the height of his professional success, he built a mansion on the East

River near what is now Fifty-first Street. The name of the mansion was Mount Pleasant, and it was filled with fashionable imports and the finest locally made furnishings. The Beekman family also had a coat of arms painted prominently on the coach and presented in carved wood (to hang in the parlor).

James Beekman, like many of his contemporaries, supported independence for the American colonies. Moreover, during the war he used his considerable merchant fleet fortune to secretly help finance Gen. George Washington's Continental army. After the war, Beekman faced an awkward American dilemma. He found the allure of genteel culture irresistible, but its association with monarchy and the trappings of nobility was inconsistent with the values of simplicity, virtue, and freedom espoused by the new republic. The most famous post–Revolutionary War procession to take place in New York was on April 30, 1789, when George Washington was inaugurated as the first president of the United States. Surviving newspaper accounts report a fascinating carved and gilded English-made coach drawn by four horses that carried Washington from his home on Cherry Street to Federal Hall on Wall Street. Washington's secretary Tobias Lear observed of the ceremonial coach, "It was so elegant that some persons professed to think it too pompous for a Republican President."

Again the trail for the official name of Mount Pleasant goes cold. There is no official evidence that Washington rode in Beekman's coach, but there is a strong likelihood that one of the clandestine bankers of Washington's army would hold huge sway over the new president. Moreover, Beekman often entertained elite New Yorkers who supported independence in his Mount Pleasant mansion, and many of them were the same legislators who incorporated Mount Pleasant. And finally, it was well known that Beekman wanted Frederick Philipse's manor so his family could dominate trade on the Hudson River. After the war he was allowed to purchase the largest tract of land in Mount Pleasant from the office of forfeiture. So although one of the initial objectives of this book was to document the name Mount Pleasant, the authors respectfully present this information for the readers to draw their own conclusions.

The narrative has used a broad brush to cover the history of Mount Pleasant. The following are the highlights of the rich history of Mount Pleasant. The history starts when Frederick Philipse wanted people to come and live without charge on his land so that the mill on his manor could be quickly put to use. (This policy only lasted a few years, and afterward tenant farmers became the norm.) The early settlers built homes, farmed, and traded. The first family to officially settle in the Neperan Valley of Mount Pleasant was Isaac and Mary See (or Sie), who settled at the Four Corners in Thornwood in 1695. The 150-acre See farm extended into Pleasantville and produced grain, vegetables, fruit, and maple syrup, as well as livestock for meat, skins, and wool. Members of the See family would journey on Native American trails along the Saw Mill River to mill their grain in Philipsburg Manor and to attend services at the Old Dutch Church. In fact, Jacobus See would eventually become the deacon in 1701 and again in 1715.

James Pierce, William Leggett, Samuel and Joseph Haight, Ananias Matthews, and Edward Buckbee brought their families to Mount Pleasant nearly 40 years after the Sees and rented land in Pleasantville from the manor. The Underhill brothers, Abraham, Isaac, and Jacob, rented in Thornwood near the Sees in 1738. One of the brothers built a home that still stands today at 3 Rolling Hills in Thornwood. Thomas Dean followed shortly thereafter and rented his homestead on Eaton Road. Zephaniah Birdsall rented at Halls Hill, now called Reynolds, in Valhalla in 1746. He was followed by Staats Hammond. Early manor renters of Hawthorne included John Brett, Caleb Oakley, John Foshay, Joshaua Paulding, Isaac Twitching, Samuel Purdy, and John and William Yerks.

The Revolutionary War brought conflict to the doorstep of Mount Pleasant. The British army left New York City with a detachment of Hessian mercenaries and ventured into Westchester County in early October 1776. Soon afterward, a battle was fought at White Plains that slowed the British advance, but the Continental army was forced to retreat.

Hence, when 38-year-old Gen. Benedict Arnold took command of West Point on August 3, 1790, he single-handedly controlled the success or failure of the Revolution. Unknown to

General Washington or anyone else in the Continental army, Arnold had established contact with the British in May 1779 with the express purpose of surrendering West Point to the enemy. However, Arnold's plan to turn the tide of the Revolution ended in Mount Pleasant on September 23, 1780.

Some families who ventured north into Putnam and Dutchess Counties never returned to Mount Pleasant after the Revolutionary War. Those that did primarily turned to farming. During the winter, families normally engaged in shoemaking, weaving, and cooperage—the making of barrels to the New York City trade. The barrels were made largely for the southern molasses trade. After completion, the hoops, staves, and heads were bound separately but marked so that they could be easily reassembled. In 1814, a Pleasantville cooper shop obtained a very large contract of barrels for shipment to New Orleans. When they were ready for shipment that fall, two young men from the shop, Daniel See, age 24, and Daniel Hadley, a stout 17, were sent with the shipment to reassemble the barrels in New Orleans. They reached New Orleans and found the city in a "ferment of excitement," as news arrived that a force of 12,000 British regulars under the command of Sir Edward Pakenham had landed nearby on December 10 and were working their way through the swamps of the Mississippi.

Gen. Andrew Jackson, "with terrific energy," gathered a nondescript collection of motley fighters that totaled 6,000 and included Tennessee and Kentucky backwoodsmen, Creoles, regular soldiers, sailors, free black men, old French soldiers, Baratarian pirates, and last but not least, the two young Pleasantville coopers. General Jackson ordered his men to build breastworks, largely of cotton bales, and prepared to defend the city. On January 8, 1815, the British attacked. In a half hour the battle was over. General Pakenham was dead, and 2,600 of the British army were killed or wounded. The Americans suffered 8 killed and 13 wounded. It was arguably the greatest victory in American military history.

In 1909, the board of water supply awarded contracts to build a new Kensico Reservoir that would be able to hold a 50-day supply of Catskill water. The big new reservoir, which would hold 30 billion gallons, would dwarf the original Kensico Reservoir. More than 1,500 workers toiled on the Kensico project. They included men of all races and nationalities. Many of them lived in the principal work camp maintained by the contractor that consisted of 24 houses that accommodated 24 single men each. The camp was divided into Italian and American sections. Workers in camp paid 50¢ a day for housing and 35¢ a day for food at the company kitchen. White workers were paid $1.50 daily, while African Americans were paid $1.25 and all Italian workers, including the stonecutters, were paid $1 daily. However, some workers lived in nearby communities and rode bikes to work every morning.

Many of the Italian workers who lived outside the company camp resided in Pleasantville, in a small neighborhood that was commonly called "the Flats." The name derives from the fact that the only large apartment building in Pleasantville was built there and anyone who needed a "flat" or apartment to rent could find it there. The four-floor apartment building was called "the Brick House" by the Italian community, and it is still standing today on Saratoga Avenue. The Italian Sicilian community in Pleasantville would eventually become a vibrant part of Mount Pleasant. The Aucello, Cacciola, Camilli, Cangelosi, Cannizzaro, Cedrone, Cristofalo, De Grazia, Gianotto, Molinaro, Pagano, Raguso, Reale, and Siciliano families (among others) would form the core of a proud community that in 1918 would build the Our Lady of Pompeii Church on Saratoga Avenue for free. The history of Mount Pleasant has consistently been filled with dedicated Americans who put their community first. The authors are very pleased to report that the proud tradition of "community first" is alive and well.

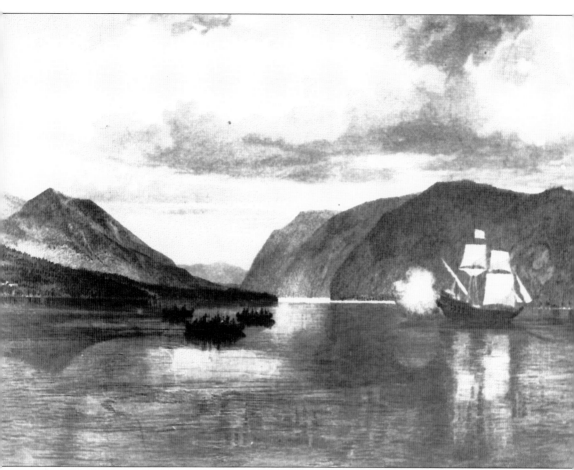

In 1609, Henry Hudson, an English explorer hired by the Dutch East India Company, arrived at the mouth of the Hudson River. Although sighted by Giovanni da Verrazano in 1524, the Hudson River was not explored before September 11, 1609, when the *Half Moon* continued its voyage northward up the river. Verrazano decided not to continue exploring the waterway but named it Grandissima Riviera. He also wrote that, "We found a very pleasant situation amongst some steep hills." Hudson was also impressed with the beauty before him and noted in his journal that when he gazed from the deck, "It is as pleasant a land as one need tread upon." (Courtesy of the Westchester County Historical Society.)

One

THE EARLY YEARS

Mount Pleasant was originally occupied by a peaceful race of hunting, fishing, and farming natives known as the Weckquaeskecks. They were members of the Wappinger Confederacy within the powerful Algonquin Nation. The men fished and hunted animals and birds with bows and arrows, nets, spears, and by trapping. The fish and game provided the Native Americans much of their food and all their clothing. The women planted fields of maize and patches of corn, squash, beans, and pumpkins. All their land and most belongings were held in common, and they lived in very long houses.

When the Algonquins saw Henry Hudson's Dutch ship the *Half Moon* in the fall of 1609, some thought it was a giant sea monster. Others thought it was a floating house of the creator. They could not imagine that his arrival would eventually mark the end of their traditional way of life. Henry Hudson was a highly regarded English explorer hired by the Dutch East India Company to find a better all-water route to Asia. The Dutch had a monopoly on trade with the Orient and wanted to avoid the expensive and dangerous voyage around the Cape of Good Hope. They provided Hudson with the 85-foot *Half Moon* and a crew of about 20 men to sail eastward through the polar regions to reach the Far East.

The *Half Moon* sailed from Amsterdam in April 1609 and headed northeast along the coast of Norway. However, after encountering ice and cold that blocked his passage, Hudson turned and headed west. He arrived in Cape Cod in August. He then proceeded south to the Chesapeake and Delaware Bays but found they were not the entrances to the passage he was seeking. Hudson then sailed north and anchored off the northern tip of Manhattan in September where his crew traded for oysters with Native Americans. The next night Hudson anchored off present-day Yonkers and then voyaged farther north to the mouth of the Pocantico. Hudson noted in his journal it was "as pleasant a land as one need tread upon."

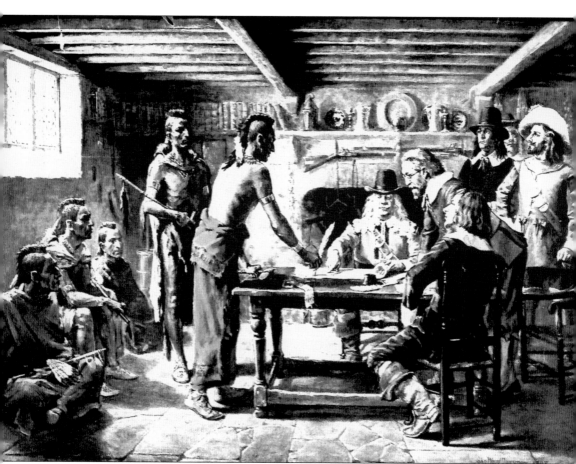

Settlers in America sought binding agreements in the form of a signed treaty. It is difficult to determine if the natives truly understood the terms and conditions of the agreements. In the painting *Jonas Bronck* by John Ward Dunsmore, Native Americans are signing a treaty in 1642 in the home of Jonas Bronck, for whom the Bronx River and New York City borough were named. (Courtesy of the Westchester County Historical Society.)

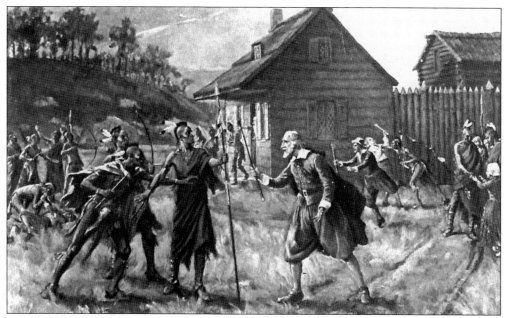

Adriaen Van der Donck was the first lawyer in the New Netherlands. In 1646, he purchased a 16-mile section of land from Native Americans in what was to become Westchester. Van der Donck died before the September 1655 attack shown in this painting, where three farmhands were killed and a young girl was kidnapped by natives. *Attack on Van der Donck's Home* was painted by John Ward Dunsmore. (Courtesy of the Westchester County Historical Society.)

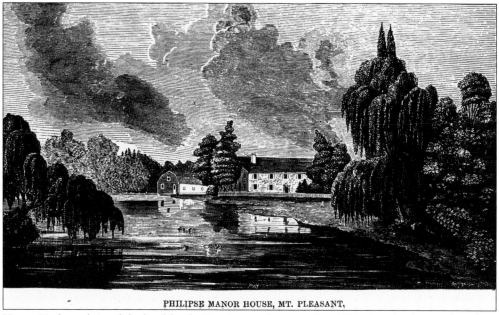

PHILIPSE MANOR HOUSE, MT. PLEASANT,

Henry Hudson claimed the land for the Dutch upon his arrival in 1609. Shortly afterward, traders, settlers, and eventually a New Amsterdam governor followed. However, Dutch dominance gave way to English colonial rule in 1664. Frederick Philipse, a wealthy real estate investor, purchased large tracts of land along the Hudson River and constructed a mill and manor house by late spring 1682. Much of the Philipsburg Manor property has been preserved to its original form.

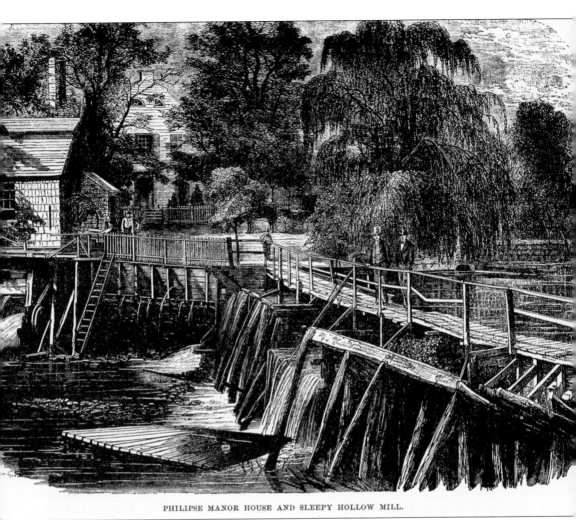

PHILIPSE MANOR HOUSE AND SLEEPY HOLLOW MILL.

In early 1700, Philipsburg Manor was an important American trading center. Here one can see the oak dam across the Pocantico River and a churning mill wheel. Note the water flowing over the dam's spillway and the handsome walkway above it. Within decades, the port at Philipsburg Manor would be one of the richest and most populous parts of the state.

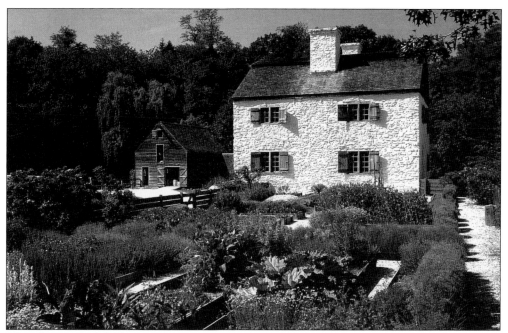

The whitewashed fieldstone manor house built in the early 1700s stands in close proximity to the mill and would have commanded a view of the harbor where the Pocantico River met the Hudson and where sloops sailed between Philipsburg and Manhattan. Like many houses of the time, the manor house is built partially underground to create a cool storage cellar and is sited toward the south to take advantage of the sun's exposure in the winter.

Frederick Philipse and his second wife, Catharine Van Cortlandt, built the Old Dutch Church in 1699. It was built about 150 yards from the manor house. The steeple holds the same bell cast in the Netherlands bearing the inscription, "Si Deus Pro Nobis Quis Contra Nos – 1685" ("If God be for us, who can be against us?"). (Courtesy of the Westchester County Historical Society.)

Frederick Philipse and his wife Catharine used the coat of arms in the family Bible and all records of the Sleepy Hollow Church.

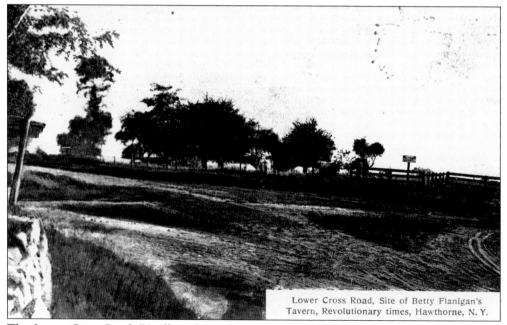

Coat of Arms and Signatures of the Founders of Sleepy Hollow Church.

THE LAST WILL AND TESTAMENT OF FREDERICK FLIPSE.

In the name of God, amen. I Frederick Flipse of ye city of New York being in health of body and of sounde and perfect memory, thanks be to Almighty God, doe make and declare this to be my last Will and Testament in manner and forme following Revoking and Annulling all former Wills and Testaments by me made either by word or writing. First, I surrender and bequeath my soul into ye mercyfull hands of ye infinite God who gave it, and I order my body to be interred at my buriall place at ye upper mills with such charges and in such decent manner as to my executors, herein after named, shall seem concient ; and as touching and disposing of my lands, tenements, hereditaments, goods, chattels and credittes I will, devise and dispose of them as follows: I give, grant, de-

ª Copied from the Bible of Catharine Van Cortlandt now in possession of Gen. J. Watts De Peyster, of New York.

Lower Cross Road, Site of Betty Flanigan's Tavern, Revolutionary times, Hawthorne, N. Y.

The Lower Cross Road (Knollwood Road) would eventually become a major artery in the economic growth of Mount Pleasant.

Two

THE REVOLUTIONARY WAR

The controversy between England and America, which began in 1763, was of little concern to the farming families of Mount Pleasant. The Stamp Act did not worry them, and the 3¢ tax on tea did not amount to a great deal to any of them. However, when England threatened to close the Port of New York in 1774, farmers worried about the price of grain, as well as the exportation of sheep to population centers, and started to take note as best they could of the hotly contested debates in New York, Boston, and Philadelphia.

Most of the tenant farmers and laborers in Mount Pleasant looked favorably upon the American Revolution. They were not freeholders (unencumbered by debt); therefore, they were not entitled to vote. Consequently, they resented the immense power of the landlords, particularly the third and last lord of Philipsburg Manor, the great-grandson of the original Frederick Philipse. News from Massachusetts of the battles of Lexington and Concord on Sunday, April 23, 1775, spread quickly along the American East Coast. Shortly thereafter, representatives of the king of England lost control of Mount Pleasant trade and political affairs. The exact date was May 8, 1775. The event was a gathering in White Plains that elected 12 members to the Provincial Congress of New York and appointed a local revolutionary committee of 90 members.

When the Continental Congress resolved on the formation of a national army, it ordered New York to raise four patriot regiments to protect the "Continental Line." One of these, the 4th, although credited to Dutchess County, was commanded by John Holmes of Bedford and contained three companies from Westchester County. Some of the officers and enlisted men for the three Westchester companies came from Mount Pleasant. Within months, some of them participated in the Battle of Fort Ticonderoga. Ultimately, Mount Pleasant farmers risked everything for the idea of freedom from imperial rule.

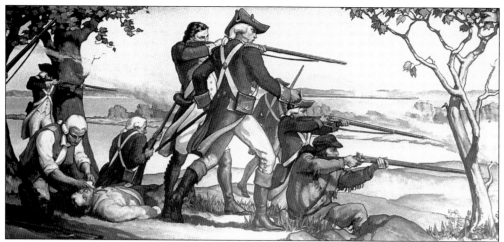

News from Massachusetts of the Battles of Lexington and Concord on Sunday, April 23, 1775, spread quickly along the American East Coast. In this Mamaroneck Library mural, local militia join the Continental army in a skirmish. (Courtesy of the Westchester County Historical Society.)

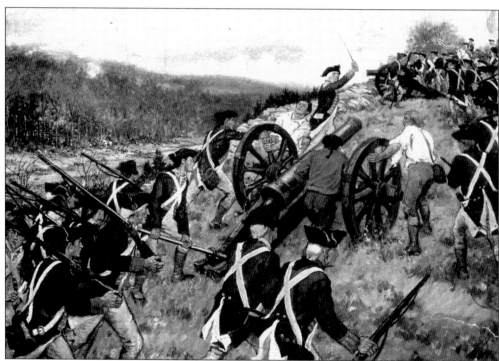

The British army left New York City with a detachment of Hessian mercenaries and ventured into Westchester County in early October 1776. The Battle of White Plains took place on October 28, 1776. In this painting, artillery captain Alexander Hamilton is seen leading his forces up Chatterton Hill. American forces slowed the British advance, but the Continental army was eventually forced to retreat. (Courtesy of the Westchester County Historical Society.)

SCHEDULE OF THE NUMBER OF THE INHABITANTS IN THE COUNTY OF WESTCHESTER FOR 1790, TAKEN FROM THE TOWN RECORDS OF BEDFORD.[a]									
No. of Heads of Families.	Townships.	Free White Males of 16 years and upwards.	Free White Males under 16 years.	Free White Females, including Heads of Families.	All other Free Persons.	Slaves.	Aggregate Total.	More Females than Males.	More Males than Females.
13	Morrissina	43	17	41	2	30	133	19
170	Westchester	279	212	421	49	242	1,203	70
102	Eastchester	174	160	320	11	75	740	14
31	Pelam (or Pelham)	45	31	84	1	38	199	8
152	Yonkers	265	220	458	12	170	1,125	27
2:3	Greenburgh	330	323	616	9	122	1,400	37
109	New Rochelle	170	130	277	26	89	692	23
33	Scarsdale	73	53	113	14	28	281	13
65	Mamaroneck	108	98	171	18	57	452	35
162	Rye	258	154	427	14	123	986	5
192	Harrison	242	220	453	35	54	1,004	9
75	White Plains	130	100	218	8	49	505	12
303	Mt. Pleasant	501	422	909	8	84	1,924	14
400	North Castle	608	593	1,205	43	29	2,478	4
420	Bedford	618	622	1,182	10	38	2,470	58
186	Poundridge	247	270	538	7	1,062	21
260	Salem (now Lewisboro)	366	326	7.8	14	19	1,453	36
180	N. Salem	266	239	509	15	28	1,058	4
189	Slephen (now Somers)	343	297	612	7	38	1,297	28
262	York (now Yorktown)	389	381	771	28	40	1,609	1
326	Courtlandt	484	452	905	25	66	1,932	31
		5,939	5,330	10,958	357	1,419	24,003	79	390

The foregoing is a schedule of the numbers of the heads of families and inhabitants of the County of Westchester by the respective towns as taken by the Deputy Marshall in pursuance of an ordinance of Congress taken the current years 1790 and 1791.　　　a Bedford record No. 4.

Robert Bolton was a highly regarded historian and published this 1790 census in the 1848 book titled *A History of the County of Westchester*.

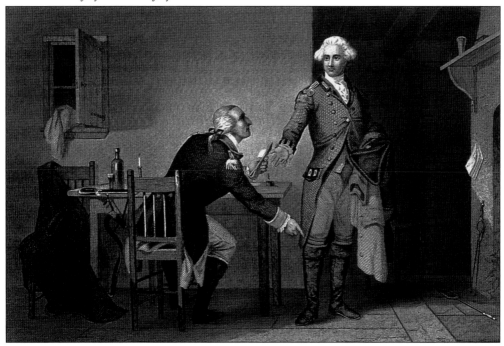

Gen. Benedict Arnold, the hero of the battles of Lake Champlain and Saratoga, took command of West Point on August 3, 1790. Arnold had established contact with the British in May 1779 with the express purpose of surrendering West Point to the enemy. He was sending coded messages to British forces in America through Maj. John Andre. In this painting, Arnold is persuading Andre to hide the plans to West Point in his boot. (Courtesy of the Westchester County Historical Society.)

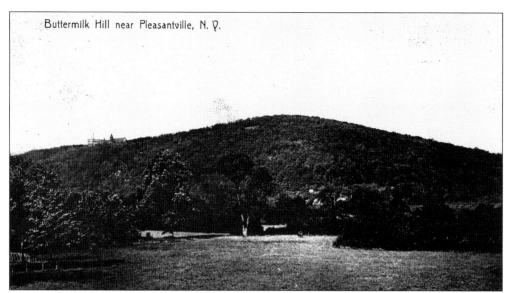

Buttermilk Hill near Pleasantville, N. Y.

Many families completely abandoned their farms and ventured north because of the danger in the "Neutral Ground." Those that stayed drove their cows to Buttermilk Hill, the northernmost of the Pocantico Hills near Hawthorne Circle, one of the highest hills in Westchester County, to protect them from foraging parties. They kept the cattle there and made and stored butter. Local residents went up the hill and brought down butter and pails of milk.

The Continental army defeats at White Plains and Youngs' Corners left Mount Pleasant farming families without protection. As a result, the land between the American lines north of Croton and the British lines in Kingsbridge was commonly called Neutral Ground. Outlaws plundered and fought throughout Neutral Ground. The pro-British groups were called "cowboys," and the pro-American groups were called "skinners." A chilling account of the lawlessness that took place in Neutral Ground came from Judge Samuel Youngs, who wrote that "No man went to his bed but under the apprehension of having his house plundered or burnt, or himself or family massacred before morning." In 1777, the cowboy corps consisted of four troops of light dragoons and seven companies of infantry. *Cowboy* was painted by Charles Lefferts. (Courtesy of the Westchester County Historical Society.)

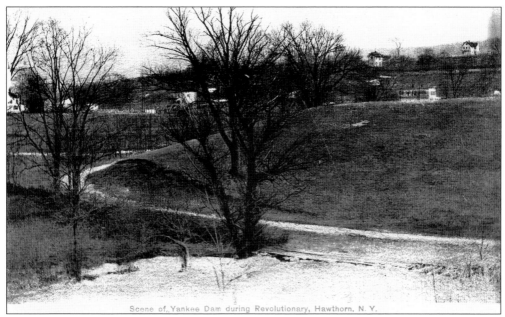

Local Mount Pleasant militia constructed many defensive earthwork positions during the Revolutionary War to circumvent British occupation. This scene in Hawthorne is a dam constructed near Brett's Tavern (close to the traffic circle) where the Flykill Brook flows into the Saw Mill River. The dam was created in order to slow the progress of British troops. As late as 1886 the dam was visible and known as the "Yankee Dam."

Brett's Tavern in Hawthorne was a pre-Revolutionary center of activity. Gen. George Washington was often seen there. The proprietor of Brett's Tavern, John Brett, witnessed a bloody murder in his public room when two American soldiers stopped in on their way home with their honorable discharges. Soon afterward, a British dragoon rode up and fired two pistols through the window, dismounted, and rushed inside to kill both wounded men with his sword.

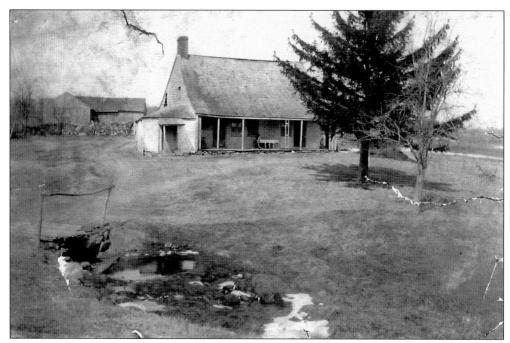

Torn down long ago, this old Revolutionary house was located in Valhalla and belonged to Reese Carpenter. The Carpenter house was the next target after the defeat of the Continental army at Youngs' Corners. It housed several American soldiers who were recovering from smallpox. The British forced all the sick men out into the deep snow, causing their deaths. The house was formerly located on what now is the Westchester Community College campus. (Courtesy of the Westchester County Historical Society.)

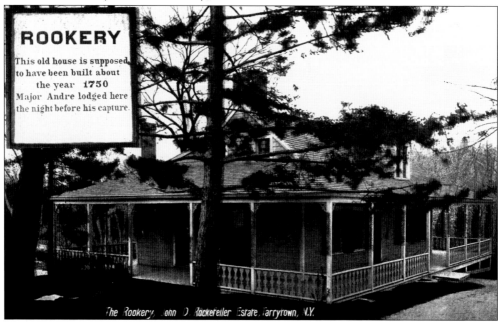

The Rookery was reportedly built in 1750, and British major John Andre lodged there the night before his capture.

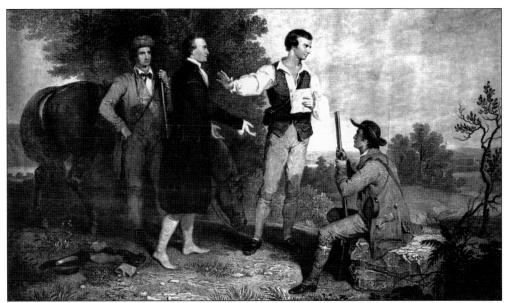

Gen. George Washington was of the opinion that all of New York "was of vast importance" during the Revolutionary War because he who controlled the Hudson River would in turn control Lake Champlain and the corridor from New England to Canada. John Adams called New York "a kind of key to the whole continent" and said that "no effort to secure it should be omitted." Fortunately, Andre was outsmarted by three local militia, John Paulding, Issac Van Wart, and David Williams, who found Andre's highly educated behavior suspicious, conducted a body search, and discovered the secret documents. The capture in Mount Pleasant, which ended Benedict Arnold's plans of betrayal, was arguably one of the most important moments of the American Revolution. After the war, the New York legislature granted the three captors 500 acres of farmland, and when Ohio gained statehood in 1803, it named three of its counties after each of the three captors. *The Capture of Major Andre* was painted by A. B. Durand.

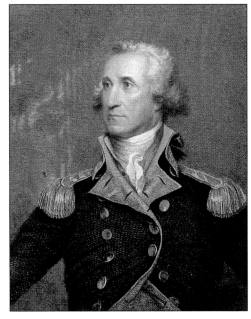

This is *George Washington*, engraved by A. B. Durand from the full length portrait by Col. John Trumbull belonging to Yale College. Born in 1732 into a Virginia planter family, George Washington learned the morals and body of knowledge requisite for an 18th-century Virginia gentleman. When the Second Continental Congress assembled in Philadelphia, Washington, one of the Virginia delegates, was elected commander of the Continental army. On July 3, 1775, at Cambridge, Massachusetts, he took command of his ill-trained troops and embarked on a long, grueling war. (Courtesy of the Westchester County Historical Society.)

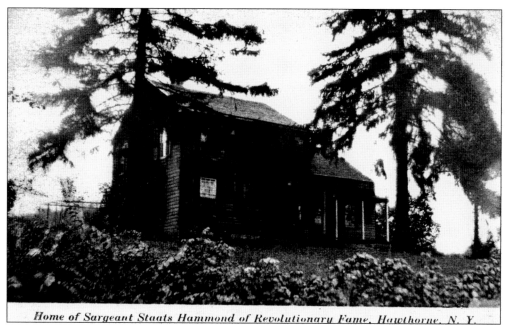

Home of Sargeant Staats Hammond of Revolutionary Fame, Hawthorne, N. Y.

Staats Hammond served on the staff of Gen. George Washington as an orderly during the Revolutionary War and was wounded at the Battle of Trenton. His brother was Col. William Hammond, who fought in the Battle of White Plains and was afterward captured and spent nearly two years in jail. This 1910 postcard is of the Staats Hammond home in Hawthorne.

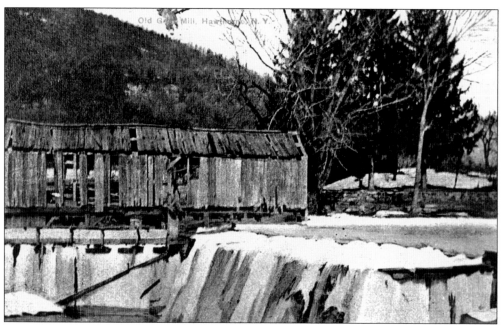

Staats Hammond built two sawmills before the Revolutionary War. This 1911 postcard is what is left of his mill in Hawthorne. The other mill was located in Eastview.

Three

FARMERS AND THE UNDERGROUND RAILROAD

At the conclusion of the Revolutionary War, state officials wasted little time and immediately confiscated the large estates of British loyalists in an attempt to reduce the heavy debt accumulated during the long years of war. The New York legislature appointed Isaac Stoutenburgh and Philip Van Cortlandt "commissioners of forfeitures" for the southern district of the state to facilitate the "speedy sale of confiscated and forfeited estates." Philipsburg Manor was sold off in December 1785.

First to buy choice land were the tenant farmers from Mount Pleasant who fought in the Continental army. However, James Beekman, the grandson of William Beekman and a powerful merchant who helped finance the war effort, purchased 1,600 acres from the old manor house up to and into Tarrytown. James's brother, reportedly had a mansion in New York City at Fifty-first Street and First Avenue with the words *Mount Pleasant* on the facade, and some historians have speculated for years that he gave birth to the name of the town. (However, there are no official records to document this theory.) The families who settled in Mount Pleasant primarily turned to farming. During the winter, families normally engaged in shoemaking, weaving, and cooperage, the making of barrels, to the New York City and southern molasses trade.

Shortly after the War of 1812, one of the moral giants of Mount Pleasant was born. His name was Moses Pierce, and he was raised on the farm his family owned for nearly a century. Moses Pierce achieved fame early in life as a fearless upholder of just and right principles, regardless of its unpopularity, so much so that he risked danger to both his life and family. Moses married Edith Carpenter of New Rochelle, and he and his wife became violently opposed to slavery. Convinced it was an outrage, Moses Pierce willfully broke the law and refused to return runaway slaves. In time he partnered with the "Moses of her people," Harriet Tubman, the pioneer of the Underground Railroad.

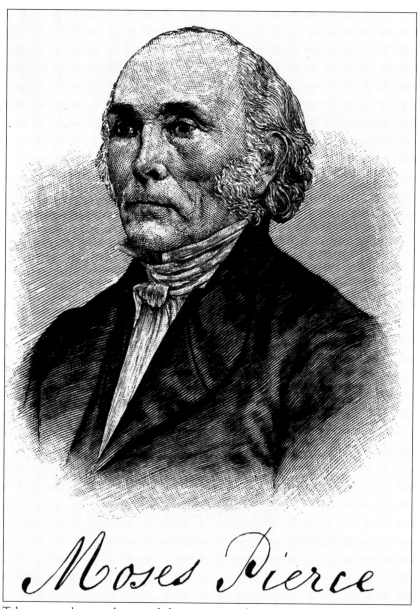

Moses Pierce

Harriet Tubman was born a slave, and she experienced cruelties of the plantation system. She escaped captivity in 1849 but kept returning to her native Maryland for family members and anyone else who wished to risk the journey north. Tubman was astute; she always started a northern flight on a Saturday night, since owners were not likely to report missing slaves and announce bounties until Monday. Tubman was also tough; small in stature, she carried a gun on all trips north and was known to say, "Move or die" to fugitives afraid to continue. Ultimately, Tubman would find posters all over the South offering a $40,000 reward for her arrest. Tubman reportedly sometimes felt it necessary to hide her "passengers" under a mound of manure with only straws for breathing. One of the most reliable "stationmasters" of Tubman's famous Underground Railroad was Moses Pierce of Pleasantville. On February 1, 1978, the U.S. Postal Service brought out a stamp commemorating the "Moses of her people." It was the first stamp in the Black Heritage U.S.A. series and was issued on the opening day of Black History Month.

A winter scene is shown in Pleasantville as a one-horse carriage travels east on Bedford Road.

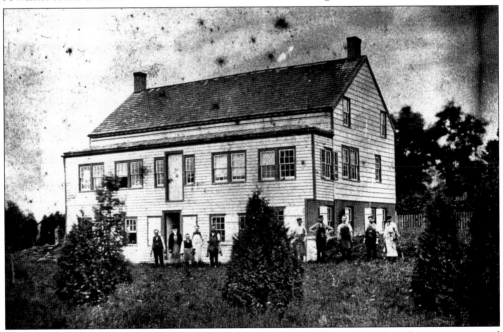

Before the American Civil War, Mount Pleasant was primarily an agricultural community, and farmers supplemented income during winters as weavers of baskets, coopers of barrels for the molasses trade, and with small barn shoemaking shops. The Civil War generated an enormous demand for boots that the metropolitan trade could not meet. Consequently, several shoe factories employing large workforces daily opened in Mount Pleasant. This photograph is of the Israel and Zarr shoe factory in Pleasantville.

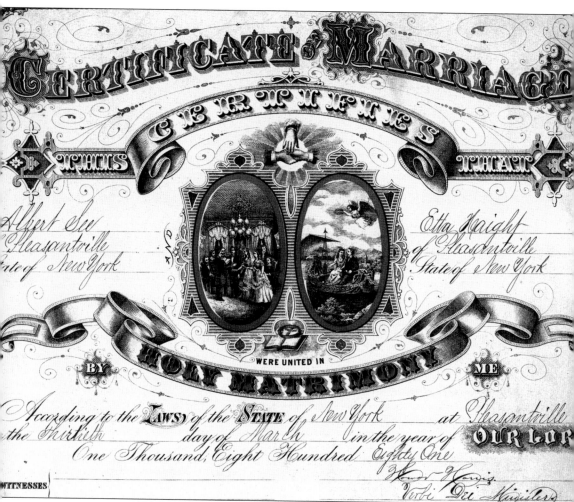

The first family to officially settle in Mount Pleasant outside of the manor was Isaac and Mary See (or Sie), who settled at the Four Corners in Thornwood in 1695. This certificate of marriage belongs to descendants of the See family who still live in Pleasantville today. Albert See was born in Pleasantville in 1858. (Courtesy of the Ripley collection.)

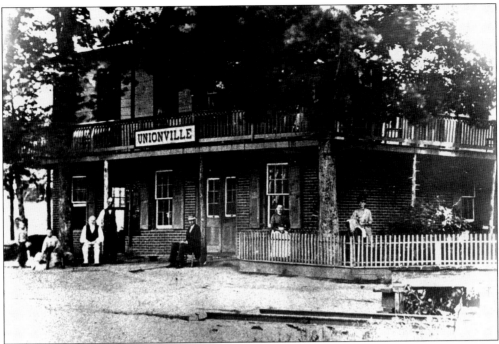

Hawthorne has had a number of different names. In 1787, it was called Hammond's Mill after owner Staats Hammond, who built a sawmill and gristmill on freehold land alongside the Saw Mill River. However, in 1818, Hammond's Mill was changed to the patriotic-sounding Unionville. Nevertheless, in 1851, the post office was called Neperan, the Native American name for the Saw Mill River. Ultimately, Unionville and the Neperan Post Office were officially named Hawthorne in 1901 after Rose Hawthorne, the founder of the Rosary Hill Home.

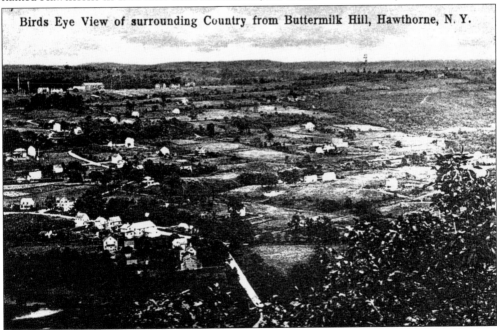

This view carefully depicts the expansive countryside nature of the early Hawthorne community.

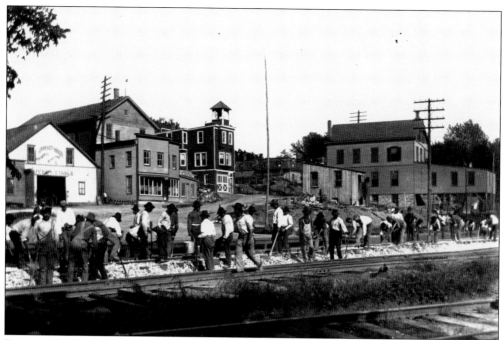

Dozens of railroad workers are put to work upgrading the track in Pleasantville. Across the street, from left to right, are Guion's Livery Stable, the Thorn Building (Sunset Hall), the fire company with bell tower, the vacant apple orchard, and Quinn's corner. (Courtesy of Russell and Alice Tompkins.)

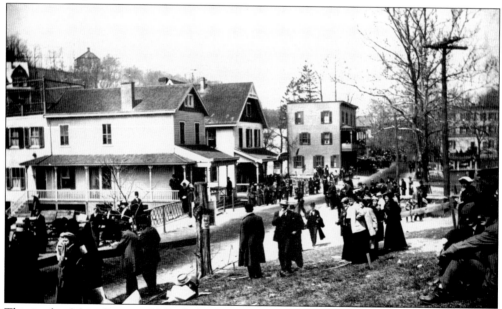

This is what Main Street in Valhalla looked like before the Bronx River Parkway was extended north through Valhalla from North White Plains in 1924. Note that stores and homes exist on both sides of Main Street. The construction of the parkway extension necessitated that all homes on the far side of Davis Brook be transported across the other side of Main Street or face demolition.

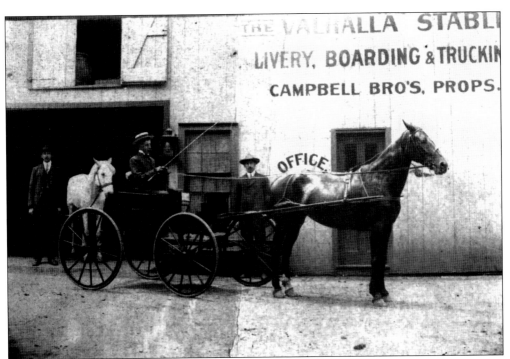

The Campbell brother's Valhalla stable was a major center for hiring transportation.

This photograph captures the now-demolished icehouse on Opperman's Pond in Pleasantville that provided Mount Pleasant residents blocks of ice to put into kitchen iceboxes. Three-hundred-pound blocks of ice would be cut from the lake during the winter with large saws. The supply of ice was so great it easily met July and August demand. Moreover, the ice was known to be very clean and fit to mix with lemonade or whiskey.

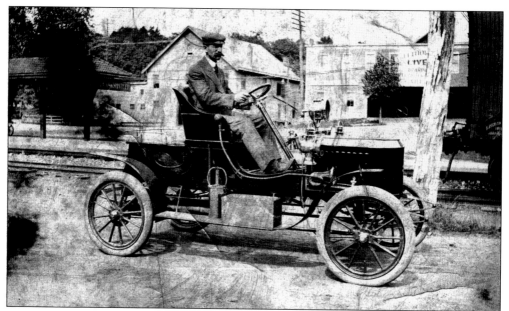

Albert See loved automobiles. In this photograph he is reportedly at the wheel of one of the first automobiles in Pleasantville. The photograph is at the Pleasantville railroad station. (Courtesy of the Ripley collection.)

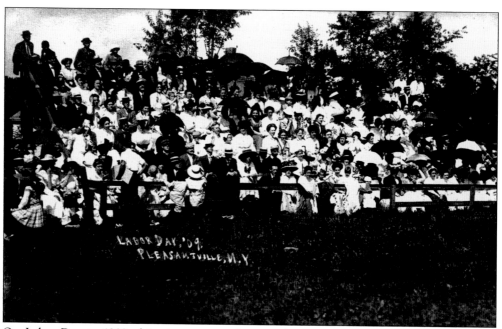

On Labor Day in 1909, this picture was taken on the west side of the field in the rear of Pleasantville High School on Romer Avenue. It was literally a who's who of Pleasantville society. Families in the picture include the Romers, Bells, Brundages, Deckers, Washburns, Carpenters, Thorns, Fowlers, Guions, Knapps, Wilcoxes, Smiths, and Moroneys.

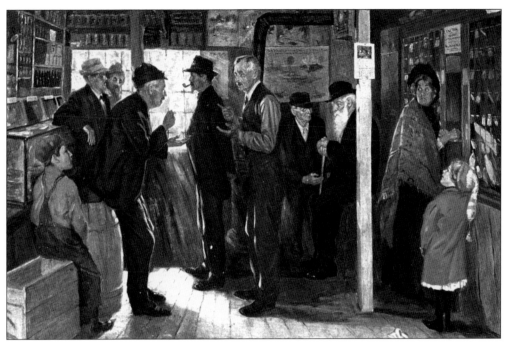

This 1910 painting of Pleasantville residents inside the See brothers' old village general store was painted by artist Alfred Dewey. The original painting hung in the office of George W. Bell's clothing store on Wheeler Avenue for nearly 50 years. Everything from molasses to gingham was sold in the general store, while the post office was on the opposite side of the building.

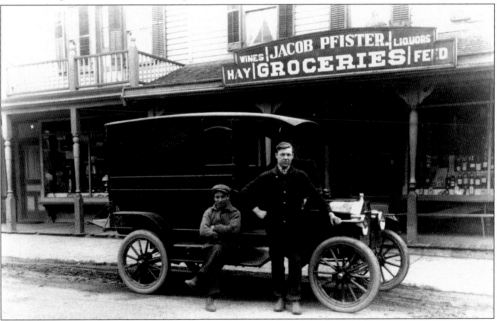

The Pfister General Store in Valhalla was well supplied with regular deliveries by the Harlem Railroad and was a fixture in the community. The store featured the sale of wines, liquors, hay, and animal feed. The Model T Ford delivery truck in front of the store was considered state-of-the-art customer service during this era.

The Pleasantville Poultry Club Competition was serious business. Westchester's Best Show for local farmers was complete with very exact details of the competition.

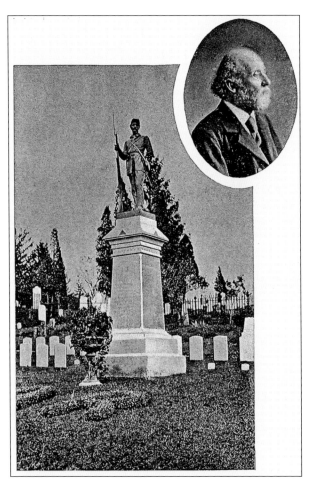

This is the soldiers monument in Sleepy Hollow Cemetery that was modeled by William H. Mundy, the blind sculptor whose portrait is in the upper corner. Just before Mundy's death, he completed a statue of Washington Irving. (Courtesy of the Westchester County Historical Society.)

Pete Riley's saloon was a Pleasantville landmark for a century, located on the corner of Pleasantville Road and Bedford Road. This photograph was taken around 1918.

Pete Riley reportedly had quite a reputation during Prohibition. The following is a published account quoting old-timers: "But one and all were loyal in their admiration of Pete. Over and over again, one of them said, those prohibition dicks tried to pull off a stunt on Pete. They could raid him every so often, load his barrels of cider into trucks, and cart it off to New York. But nary a time did they get the goods on Pete. He wasn't breakin' the Eighteenth Commandment, not even joltin' it in the ribs; and every time he was pestered that way, he'd ask the judge or the commissioner what was he going to do about it? And the judge would look over all the evidence, give a dirty glance at the officers what made the raid, and tell Pete to go long about his business . . . that they didn't have nothin' on him."

Members of the Ripley family are direct descendants of the See family, the first settlers of Mount Pleasant outside the manor. Al Ripley (left) was a Notre Dame graduate and successful local businessman. At one time he was a copartner with Dick Devine of the Brass Rail, an immensely popular bar on Washington Avenue that was well known in the tristate area. Here he is with his sister Marjorie around 1926. (Courtesy of the Ripley collection.)

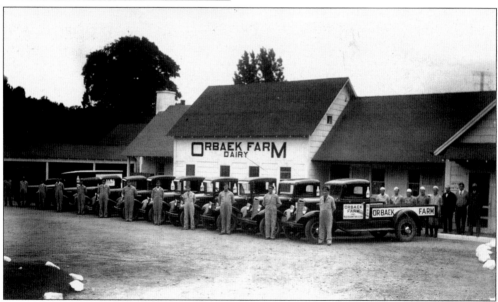

The Orbaek Farm Dairy was owned by Michael Mikkelson and operated on Lake Street in Pleasantville. He opened his business in 1922 and named it after the town he came from in Denmark. Local Mount Pleasant farmers delivered milk to Mikkelson for pasteurization. Originally, delivery was made in horse-drawn wagons with "buyer's pails." This picture shows the fleet of trucks that delivered bottled milk, chocolate milk, eggs, butter, yogurt, and cottage cheese during the 1930s. The business closed in the early 1970s.

Four

THE RAILROAD

The New York Central and Harlem Railroad arrived in Mount Pleasant in October 1846. The railroad gradually replaced the Hudson River as the principal artery of trade, particularly in the winter when the river was known to freeze. The railroad revolutionized business by allowing small merchants to stock store shelves with products from all over the East Coast. It also allowed farmers to enter into the large-scale production of milk, pickles, shirts, shoes, and boots to meet growing demand in New York City. However, locals generally were known to boast that the greatest feature of the railroad was the dramatic improvement of communication with the swift delivery of mail.

In 1865, John Mack opened the marble quarry in Thornwood. Ten years later a high-grade marble was discovered, and nearly 200 men were employed at the quarry. Stone from the quarry was used to build many fine buildings; the most famous were St. Patrick's Cathedral in New York City and the New Orleans Custom House. Within decades the railroad allowed white-collar professionals the luxury of raising families in the countryside outside the crowded confines of New York City. The railroad allowed workers the ability to commute to Manhattan in the morning and return in the evening.

In the late 1880s, the wealthiest family in the nation moved to Mount Pleasant. William Rockefeller, brother of John. D. Rockefeller, was the first of the family to settle in Pocantico Hills. William bought the ostentatious 204-room English Gothic mansion built 50 years earlier by New York baron Edward Bartlett. In 1893, John started buying large parcels of property for a country home. It included Kykuit Hill and Buttermilk Hill. Both hills were nearly 500 feet above sea level and used by Native Americans for sending smoke signals, and archives sometimes refer to them as "Signal Hill." In 1908, John D. Rockefeller completed building a classical revival Georgian mansion on Kykuit Hill that commanded a majestic view of the Hudson River. The hilltop paradise would be home to four generations of Rockefellers.

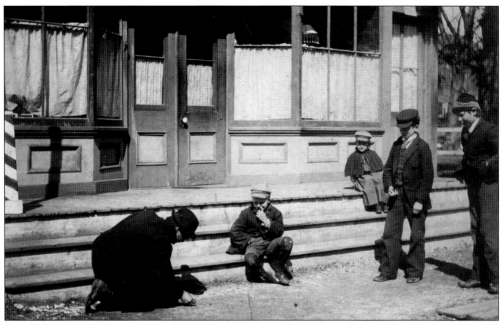

Local Pleasantville boys are seen here playing a game of marbles in front of Crolly's Store around 1890. A young girl sits on the top step patiently awaiting the end of the game while a young boy on the first step picks his nose while viewing the contest.

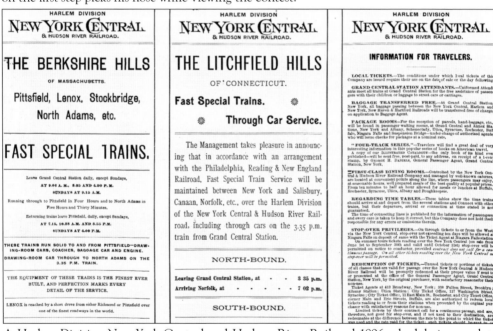

A Harlem Division New York Central and Hudson River Railroad 1896 schedule is complete with local advertisements. In addition to commuter trains from New York City to Pawling, the railroad advertised transportation to all the resorts of the famous Berkshire Hills of Massachusetts and the Litchfield Hills of Connecticut. Moreover, it advertised suburban homes along the picturesque Harlem Railroad, complete with pure air, good water, perfect drainage, agreeable surroundings, cheap commutation, and low property values.

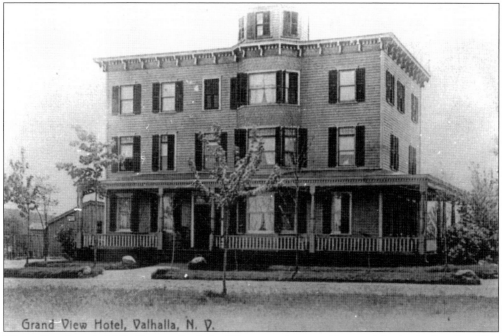

Grand View Hotel, Valhalla, N. Y.

The railroad made Valhalla a major hub. Often travelers would overnight in the hamlet. The stately Grand View Hotel had a reputation for clean sheets, fresh food, good drinks, and a scenic country landscape viewed on a beautiful wraparound porch.

In 1899, a New York City syndicate bought two large tracts of land from the Taylor and Stevens families. The land would become the Kensico Cemetery and have its own railroad station. Short of funds to challenge the syndicate to change its name, prominent members of the Kensico community led by Mr. and Mrs. A. J. Kinch banded together to change the name of the village to Valhalla. The name was reportedly suggested by Xavier Reiter, a commuter and musician with the Metropolitan Opera Orchestra, who was a Wagnerian devotee. Reiter explained that Valhalla, according to Norse myth, was "the Hall of Odin . . . into which he receives the souls of heroes slain in battle."

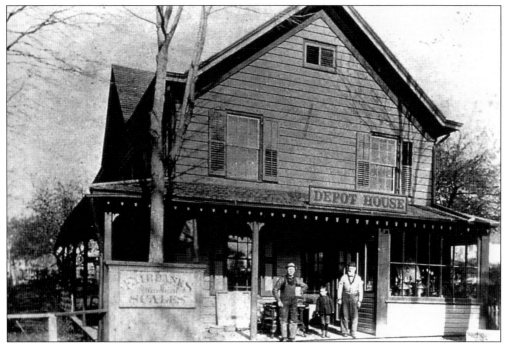

The original Pleasantville railroad depot house was built during 1846–1847 by Wilson Chapman. It was located on Bedford Road, and the railroad ran two trains daily to Pleasantville from New York City. Early station reports indicate cows suffered many fatalities as they attempted to cross the tracks in front of speedy trains.

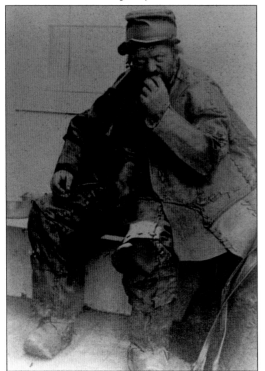

Historians have always been intrigued with the story of the Leatherman. It is believed that he was Jules Bourglay, who came from France around 1860, having left his country after a broken love affair. Always dressed completely in leather and somewhat frightening in appearance, although harmless, he was seen traveling a circuit that encompassed roughly 365 miles, every 34 days, year in and year out. He reportedly stayed in caves in the vicinity of Armonk, Bedford, Chappaqua, and Mount Pleasant, seldom speaking but stopping at farmhouses for food. In 1889, he was found dead in a cave in Briarcliff and was buried in the Sparta Cemetery near Ossining. (Courtesy of the Westchester County Historical Society.)

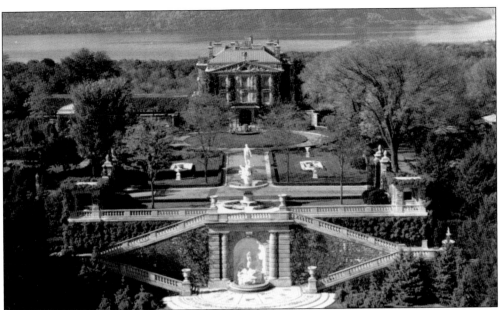

John D. Rockefeller bought a total of 17 farms totaling 3,500 acres and finally built Kykuit ("lookout" in Dutch) with this majestic view of the Hudson River. Rockefeller spared no cost, hiring architects William A. Delano and Chester H. Aldrich and landscape architect William Welles Bosworth to complete his masterpiece. Eventually, Rockefeller would use his enormous wealth and influence to reroute the Putnam Division railroad station in Pocantico Hills five miles from his property because the train's soot would soil his golf guests.

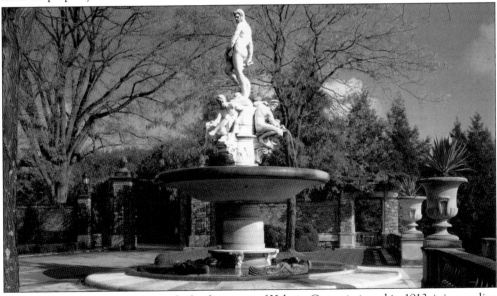

The Oceanus Fountain commands the forecourt of Kykuit. Commissioned in 1913, it is a replica of Giambologna's fountain of 1576 for the Boboli Gardens of Florence. Throughout the gardens works by George Gray Barnard, Karl Bitter, and Janet Scudder were added as part of the original garden design. More than 70 works of modern sculpture, by Henry Moore, Theodore Maillot, Louise Nevelson, and Pablo Picasso, were brought to Pocantico and sited by Nelson Rockefeller while he lived at Kykuit.

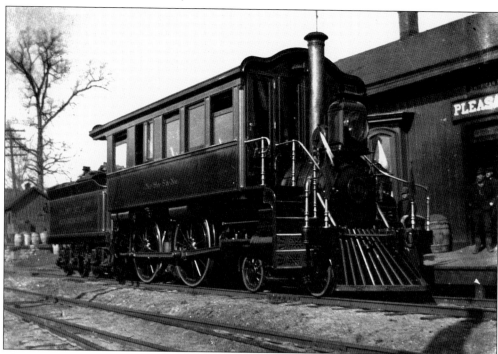

The *Ne-Ha-Sa-Ne* reportedly was a regular fixture up and down the Harlem line. In this 1885 photograph the elegant and yet very reliable locomotive is sitting at the depot house awaiting duty. There is a dearth of information as to why the locomotive was christened *Ne-Ha-Sa-Ne*.

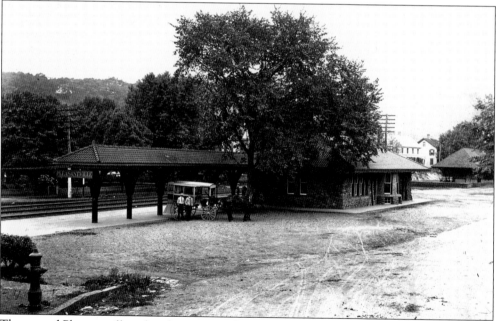

The second Pleasantville railroad station was built in 1901. The elm tree next to the station was planted during the Civil War by John I. Thorn, a local farmer, liveryman, and funeral home owner. The building on the far right served as the freight station, and the houses in the back are on Vanderbilt Avenue.

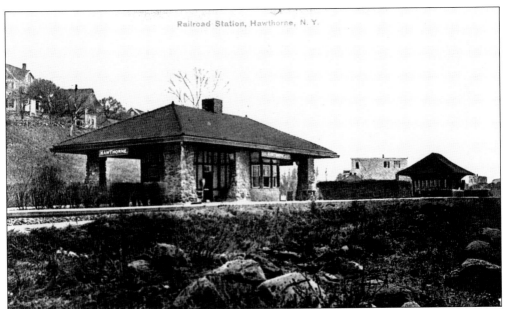

The Hawthorne station was built around 1910 at a cost of $20,000. It burned down in 1931. The blaze was discovered early, but the inability to connect water to hoses caused the total destruction of the structure, according to the stationmaster. However, all railroad records were preserved in the station safe. The Hawthorne freight station is to the right, and a scattering of houses can be seen in the distance.

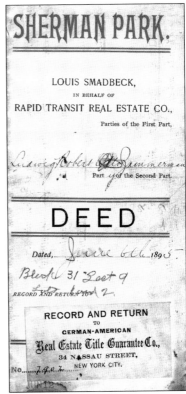

The railroad also attracted the working class. In 1890, Louis Smadbeck, a New York City real estate speculator, bought several large farms in Thornwood and Hawthorne. He then formed the Rapid Transit Real Estate Company and marketed tiny 25-foot-by-100-foot lots (ranging from $100 to $150) to the German American community in New York City. Smadbeck provided easy credit terms (5 percent cash deposit and the balance paid at $1 a week). Many families reportedly bought several lots at once.

43

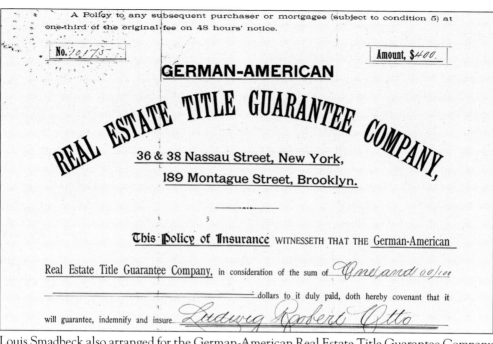

A Policy to any subsequent purchaser or mortgagee (subject to condition 5) at one-third of the original fee on 48 hours' notice.

No. 70175

Amount, $400.

GERMAN-AMERICAN
REAL ESTATE TITLE GUARANTEE COMPANY,

36 & 38 Nassau Street, New York,

189 Montague Street, Brooklyn.

This Policy of Insurance WITNESSETH THAT THE German-American

Real Estate Title Guarantee Company, in consideration of the sum of *One and 00/100*

dollars to it duly paid, doth hereby covenant that it will guarantee, indemnify and insure *Ludwig Robert Otto*

Louis Smadbeck also arranged for the German-American Real Estate Title Guarantee Company at 36 and 38 Nassau Street in New York City to provide deeds and ensure the safety of the transactions. An astute salesman, Smadbeck chartered a special train for prospective buyers every Sunday morning that left Grand Central Station and arrived in Sherman Park within one hour—free of charge.

THE CHILDREN'S THEATRE
of NEW YORK
Twenty-ninth Season

HEIDI	PENROD
PETER PAN	THE BLUE BIRD

KING MIDAS or THE GOLDEN TOUCH THE IROQUOIS CAPTIVE

SNOW WHITE AND THE SEVEN DWARFS

CLARE TREE MAJOR · PLEASANTVILLE · NEW YORK

The Clare Tree Major Children's Theatre won national acclaim. In Aberdeen, South Dakota, 1,600 enjoyed a performance of *Peter Pan*. In Cincinnati, the *Dealer* reported, "'Snow White and the Seven Dwarfs' proved one of the best things that the Clare Tree Major group has sent on tour."

44

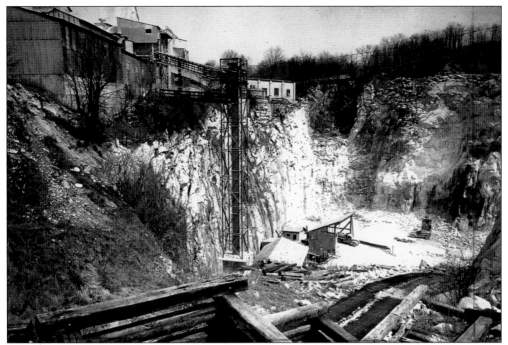

The Thornwood quarry began operation in 1865 primarily as a limestone producer. However, in 1875 a high-quality architectural marble was discovered and sold worldwide. In fact, fine marble from the Thornwood quarry was used to build St. Patrick's Cathedral in New York City and the New Orleans Customs House. After the quarry ceased operations, all that remained was a 200-foot-deep lake. The property was sold in 1972, and today it is the site of the Thornwood Town Shopping Center.

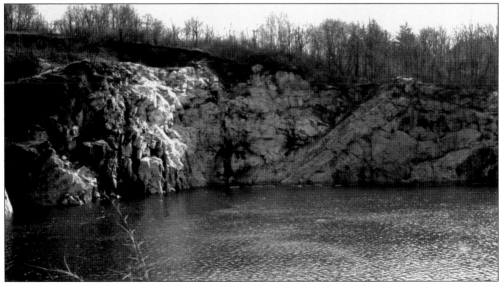

The 200-foot-deep lake at the Thornwood quarry was a popular nighttime swimming hole for Mount Pleasant teenagers during the heat of the summer. Often times swimmers would take the challenging 50-foot plunge from the top of the quarry wall into the lake. The divers would often report ice-cold water temperatures 10-feet below the water's surface.

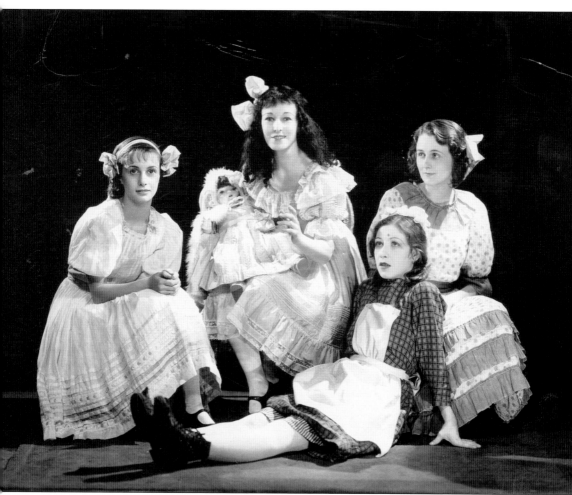

Clare Tree Major, a native of London, founded the children's theater in the giant building constructed on a rock ledge next to the Pleasantville Post Office in 1926. The railroad permitted superb New York actors access to her national touring companies. Her nationally acclaimed productions would often play from coast to coast and received the national endorsements of several prestigious academic institutions. Her touring groups included the National Academy of Theater, which had summer sessions for children and adults, and the National Classic Theater, a group formed to present Shakespearean and other plays before high schools and colleges. This photograph is a scene from *Sara Crewe*, a play based on the classic children's story *A Little Princess* by Frances Hodgson Burnett. Clare Tree Major, also the author of five books, died in 1954.

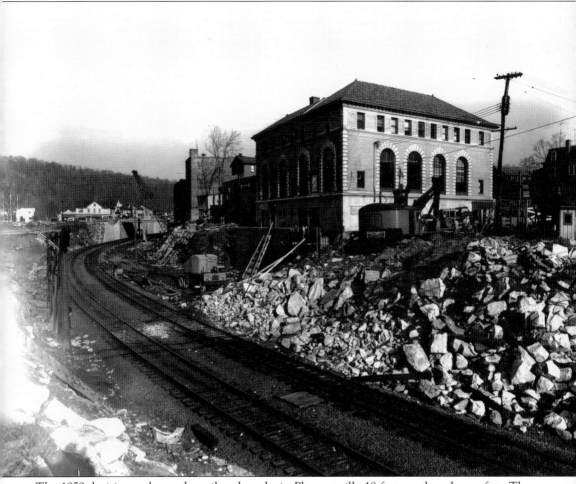

The 1959 decision to lower the railroad tracks in Pleasantville 18 feet was based on safety. The track crossing traffic over Manville Road and Bedford Road was hazardous. Sterling Silvernail, the railroad guard on the Manville Road crossing, told the *New York Times* that he would lose his job when the new bridges were opened. But, he added, he was retirement age and would still have his hobby of embroidering to keep him busy. The decision to mount the 19th-century cobblestone-and-brick station for relocation was economic. The cost of destroying it and building a new station was $100,000 while the total expense of moving the existing structure was $45,000.

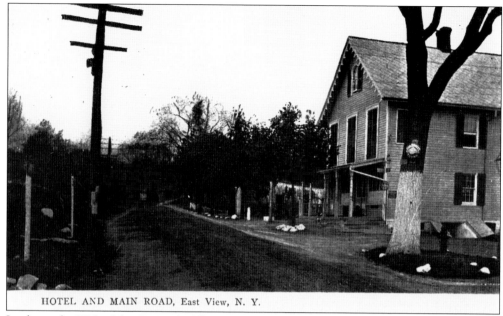

HOTEL AND MAIN ROAD, East View, N. Y.

In the early 1920s, John D. Rockefeller completed a large land transaction when he bought the entire village of East View in Mount Pleasant for $700,000 (four times the assessed value). The terms and conditions of the contract required that he then move the 46 families who were residents of East View. Rockefeller was a great philanthropist, and in 1932, he built the beautiful brick-and-stone Pocantico School to serve local residents.

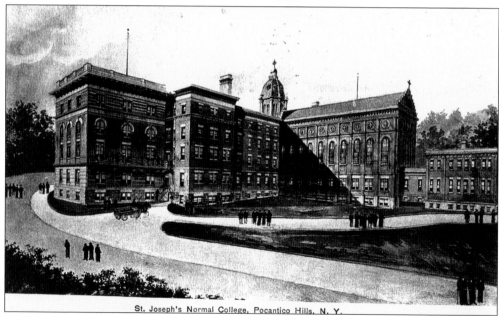

St. Joseph's Normal College, Pocantico Hills, N. Y.

St. Joseph's College stood on the highest peak of Buttermilk Hill in Pocantico Hills. It was built around 1900 by the brothers of the Christian Schools in New York City. The brothers purchased the 360 acres of land and named it Mount de la Salle, after St. John Baptist de la Salle, their founder. John D. Rockefeller bought the entire property in July 1928 and razed the buildings to add to the size of his considerable private Pocantico estate.

Five

THE KENSICO DAM

In 1875, the population of New York City was growing dramatically, and there was a critical need for more clean drinking water. City fire officials were also keen on acquiring a reliable water supply to fight large fires. The situation was dire. Health scientists estimated that 100 tons of human excrement was being put into Manhattan soil every day. At the time there was no citywide sewer system to serve the one million residents, and open pits held dead animals and offal. Travelers often declared they could smell the city two or three miles away.

Also troubling was the constant threat of cholera. Unwashed foods, garbage-strewn streets, and sewage-contaminated water spread the dread disease. The Croton Reservoir was built in the 1830s to supply the city water, but within decades it could not satisfy the city's bellowing thirst. This was evident with the great fire of 1835 that destroyed 700 buildings in a 17-square-block area and the Crystal Palace fire of 1858 in Bryant Park that melted the elegant glass and iron structure. The New York City Board of Water Supply looked north to fill its needs. One part of the solution was found in the village of Kensico, named after the Siwanoy Indian Chief Co-Ken-Se-Co. The board was able to buy a large tract of land and by 1885 completed the construction of the first Kensico Lake.

However, in time it was not enough water. So, in 1909, a new contract was awarded for a new Kensico Dam. More than 1,500 workers toiled on the Kensico Dam. They included men of all races and nationalities. However, the stone yard at the Kensico Reservoir, where there were about 80 highly skilled stonecutters, employed nearly all southern Italian immigrants. They had the responsibility for cutting 1- to 16-ton stone blocks for the dam face. Despite the need for skilled workers, the pay scale at the dam was glaringly uneven. White workers were paid $1.50 daily, while African Americans were paid $1.25 and all Italian workers were paid $1 daily.

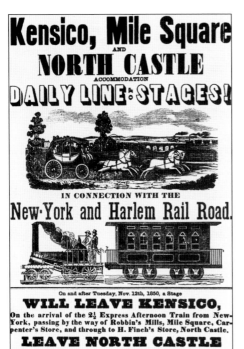

The arrival of the railroad made Kensico a thriving community. This poster advertises daily connections via handsome covered stagecoaches from the railroad station to Robbin's Mill in Kensico to Mile Square (Armonk) and North Castle (East Armonk). The stagecoach also carried mail and supplies. The construction of the dam to provide New York City with clean water would change life in Kensico dramatically, forcing many families to physically move their homes or leave the village.

In 1881, the New York City Board of Water Supply decided to build this 45-foot-high earthen dam on the Bronx River. It was completed in 1885 and created a reservoir one and a half miles long and less than a half mile wide. The 230-acre lake had storage of 1,797,000 gallons. Nearly 200 families lived in the village of Kensico, and many simply moved to higher land.

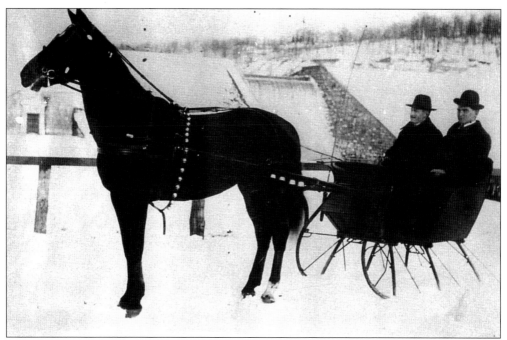

Kensico residents had no knowledge that the future would include grand plans to supply New York City with water from the Catskill Mountains and this would require the construction of a new dam that would eventually force them to abandon the entire village. In this photograph, Steve Campbell and Jim Boland ride by the dam spillway. Campbell, mindful of the needs of the community, donated the first fire equipment, a hose wagon, to the village fire company.

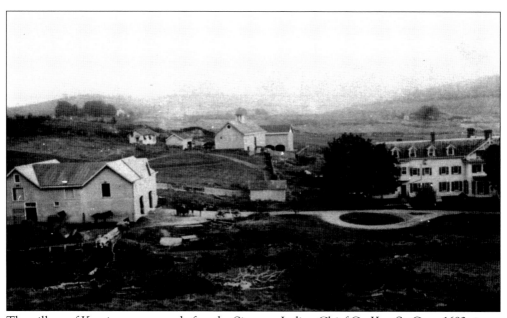

The village of Kensico was named after the Siwanoy Indian Chief Co-Ken-Se-Co, a 1683 signer of the deed for White Plains. Today the original village in this 1885 photograph is resting peacefully on the bottom of the Kensico Reservoir.

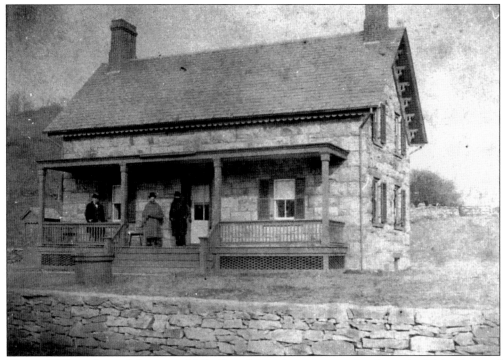

The *c.* 1885 gatekeeper's house in Valhalla is located approximately where the Holy Name of Jesus Auditorium now stands.

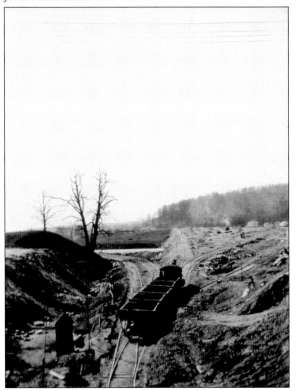

The earthen dam depended on the Bronx River and other brooks and creeks for water. The new dam would be supplied water from the Catskill Mountains by an aqueduct 92 miles in length and large enough to fit a boxcar inside. The new dam also required miles of railroad tracks, all standard gauge, so that railroad cars of cement and other material could come to the site from the Harlem Division of the New York Central Railroad. In this 1913 photograph, the emptied earthen dam is being torn down.

The Kensico Dam project captured the attention of engineers and architects the world over. The entire dam is constructed of large precast concrete blocks interspersed with cyclopean concrete. Cyclopean concrete is ordinary concrete into which 50- to 100-pound stones are placed. The downstream granite face at the front included 21 panels of squared stone separated by 15-foot-wide expansion joints made of rusticated stone projecting from the surface. Diamond patterns of dimension stone are spaced throughout the panels. The length of the dam is crowned by a richly ornamental stone band. (Courtesy of the Westchester County Historical Society.)

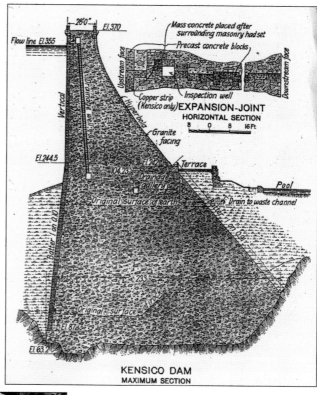

KENSICO DAM
MAXIMUM SECTION

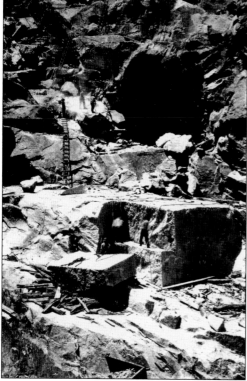

Drills and dynamite dislodged granite from the 50-acre quarry at Cranberry Lake, and four steam shovels loaded the rock into train cars. The largest charge of dynamite ever set off was on March 21, 1914, when a single blast of 32.5 tons of dynamite blew uncounted tons of rock as high as 50 feet in the air. It took 60 days to load the 142 dynamite holes ranging from 32 to 42 feet deep.

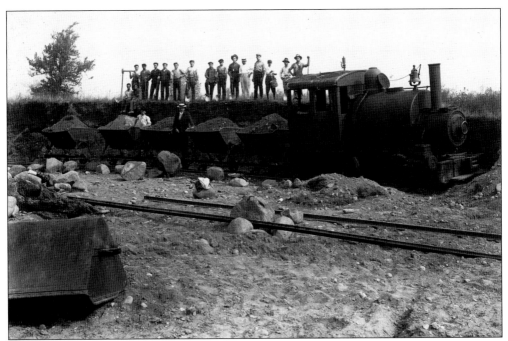

Locomotives hauled loads of rock to the crushing plant, where cars dumped their loads into a crusher. Rocks of about four inches passed through a grate, with the bigger pieces run through a second crusher, and then between two heavy rollers. In this photograph, crushed stone from the quarry was ready for transportation to the cement mixer where it would be mixed with sand excavated from a pit at the north end of Rye Lake.

This picture shows the southern entrance of Kensico around 1885. The mounted horseman is on Main Street, which was later moved to the north side of Davis Brook to accommodate the construction of the Taconic Parkway. Kensico Avenue is on the right with the horse and sleigh.

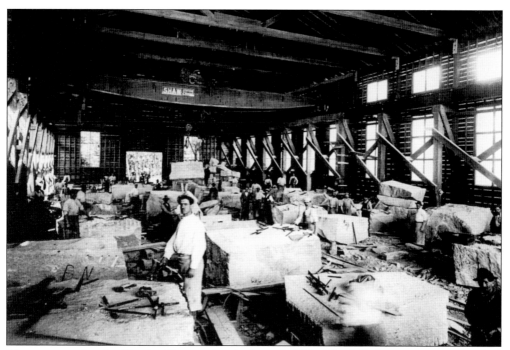

The stone yard at the Kensico Dam project had nearly 80 highly skilled stonecutters. They had the responsibility for cutting stone blocks for the dam face. Nearly all the stonecutters were southern Italian immigrants. The yard was equipped with a 25-ton electric crane, 9 surfacing machines, and 50 drilling machines.

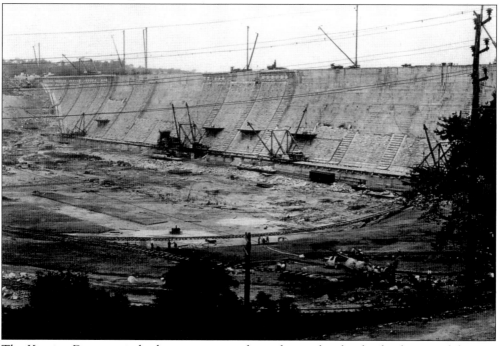

The Kensico Dam was indeed a site to see and was designed to be the focal point of the new Bronx River Parkway. In this photograph, the cut stone is being placed on the face of the dam.

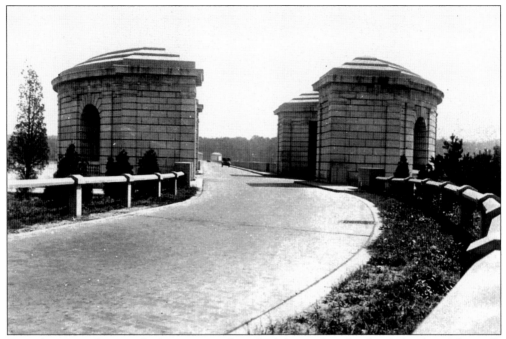

Four classic cupolas were built, two at each end of the road, to bookend the dam. The walls inside the cupolas are inscribed with the names of the many engineers and officials responsible for the construction of the massive project.

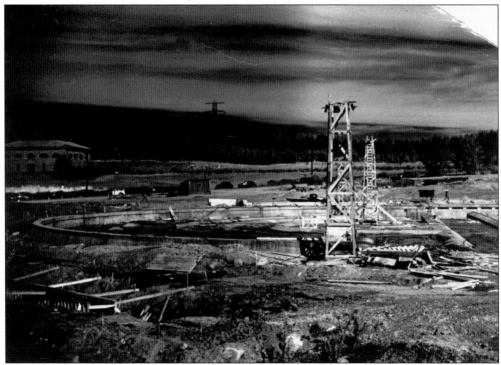

Construction of aerators took place in segments. In this photograph, the first segment is operational and the second segment is under construction.

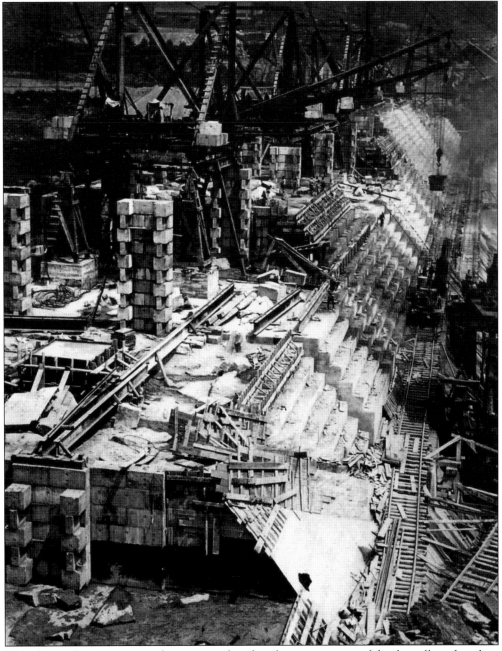

The advanced engineering techniques employed in the construction of the dam allowed work to progress at record levels. The ingenuity of the placement of temporary tracks was credited with the success.

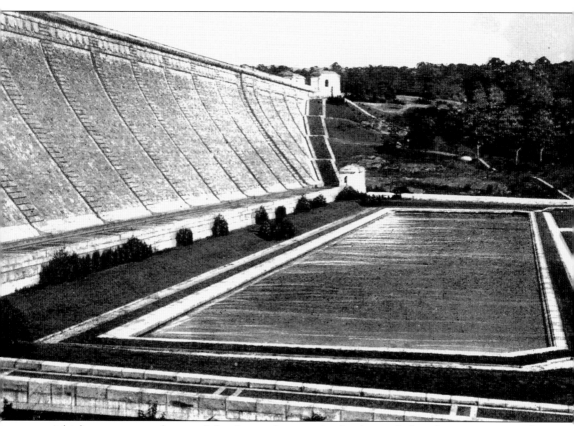

A highway traverses the top of the dam and a sweeping brick-paved plaza featuring rectangular pools landscaped with 1,176 evergreen trees and bushes spread out at its base.

Six

SCHOOLS

The very first school in Mount Pleasant was the one-room "Straw Schoolhouse." Located across from present-day Pace University in the proximity of Graham Park, the school was built in 1775. After the Revolutionary War, farming communities started a public outcry for better schools. Consequently, in 1795, the Act for the Encouragement of Schools was passed and the State of New York began the practice of funding local schools. In 1826, the Straw Schoolhouse was replaced when a school was built on Pleasantville meadowland belonging to Benjamin E. Hays located on the northeast corner of Broadway and Church Street.

In 1832, a one-room schoolhouse was built at the junction of Bradhurst and Brighton Avenues in Hawthorne. Years afterward, the *Eastern State Journal* in White Plains published an article about teaching that stated, "If a teacher could make a good quill pen and write with facility a neat and fair hand, and solve the sums and repeat the tables in Dobell's arithmetic, he or she was considered a competent teacher and received a certificate." Like everything else, the teaching profession started with humble beginnings; remarkably, some schools in Mount Pleasant today are ranked among the finest in the nation.

The first institution of higher learning was built in Hawthorne. St. Matthew's Lutheran Church of New York City erected a four-story brick building there measuring 50 feet high by 110 feet long. It was called the Concordia Collegiate Institute. The year was 1893. However, the need for expansion and a more reliable water supply prompted a move to Bronxville in 1909, where the college is still flourishing today. From 1897 to 1908, Catholic education was taught in private homes. In 1908, St. Thomas Hall in Pleasantville was the first parochial school in Mount Pleasant. It consisted of six classrooms, a large hall with a stage, and two bowling alleys. It was built on the corner of Manville Road and Tompkins Avenue. The school was moved to the corner of Orchard Street and Bedford Road (the Girl Scouts building), and the old St. Thomas Hall was torn down in 1955.

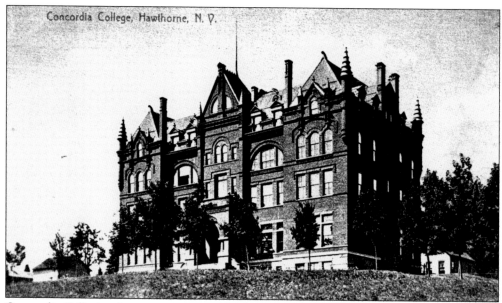

Concordia Collegiate Institute was started by St. Matthew's Lutheran Church of New York City in 1893. It erected a handsome four-story brick building. However, the need for expansion and an inadequate water supply prompted a move to Bronxville in 1909. The building was sold to the Salesian Order and became Columbus College, a school created exclusively for Italian American students. The absence of an adequate water supply would eventually doom the school when a fire on December 11, 1917, completely destroyed the building.

This 1890 Bedford Road School, Pleasantville, photograph features principal Paul Lilly (top row, center, with mustache). To the right are his two teachers, Mrs. Browning (blurred head) and Sarah Merritt (in rear with hair ribbon). In the upper left is the flamboyant Will Crolly (with the striped suit, cap, and flowing tie), who would eventually leave Pleasantville for Hollywood where he would become a pioneer in the production of silent movies.

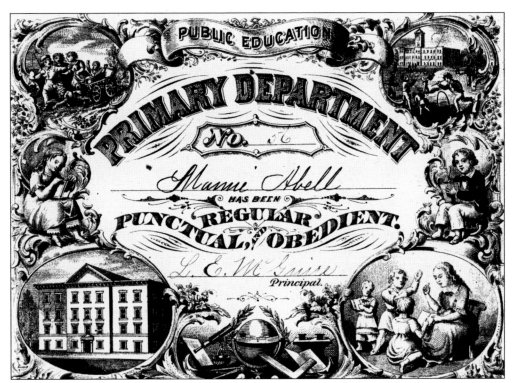

An early-20th-century Pleasantville Public Education report card, this public education primary department No. 56 report card states that Maurice Abell has been regular, punctual, and obedient. It is signed by principal L. E. McGuire.

This early-20th-century Pleasantville certificate of extra credit indicates 50 merits presented to student Arthur Bell for good conduct by teacher Grace V. Ackerly on December 23, 1897.

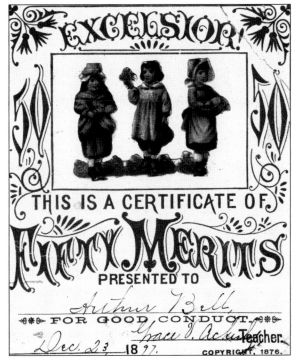

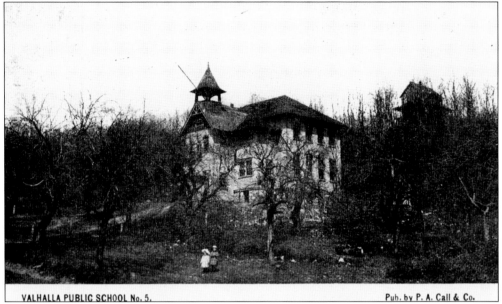

VALHALLA PUBLIC SCHOOL No. 5. Pub. by P. A. Call & Co.

The Cleveland Street School was located on the corner of Cleveland and Cedar Streets. It was constructed in 1899. It was used as a school for Valhalla students until 1919, when it was replaced by the Columbus Elementary School. The building still stands today and is used as an apartment house.

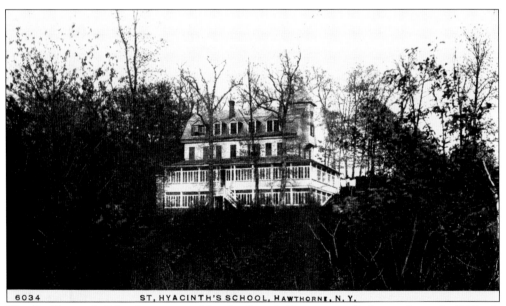

6034 ST. HYACINTH'S SCHOOL, HAWTHORNE, N. Y.

The St. Hyacinth School was started by the French Dominican Order in the early 1900s. It was one of the first formal Catholic institutions of learning in a predominantly Protestant Mount Pleasant community. When the French Dominican priests' exile ended, they returned to Lyons, France, leaving behind Fr. Alexander Mercier as superior to care for small churches in Pleasantville and Kensico. They also left behind a group of dedicated Dominican sisters who operated the St. Hyacinth School as a Catholic boarding school for boys. The school was destroyed by fire in 1932.

62

This is the official laying of the cornerstone of the new Bedford Road School on July 1, 1909. The ceremony was attended by 500 residents. A copper box was buried containing a local newspaper, photographs of each class with teachers, and a history of the school.

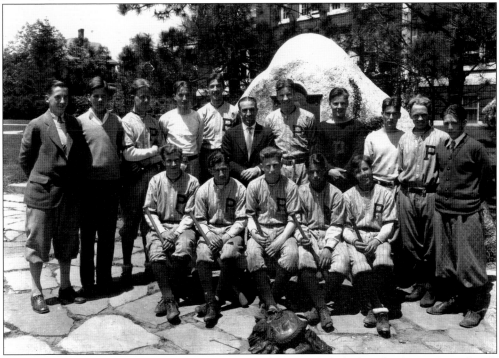

The Pleasantville High School baseball team around 1927 included Al Ripley (second row, fourth from left), who went on to the University of Notre Dame. (Courtesy of the Ripley collection.)

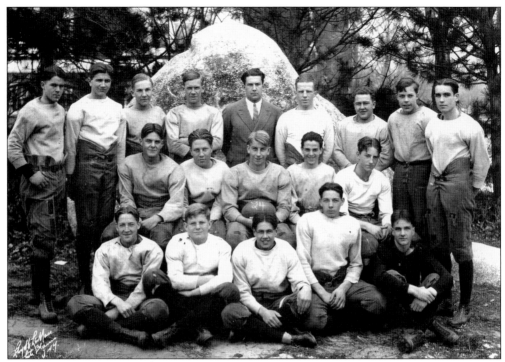

The Pleasantville High School football team of 1924 was a small squad that required most members to play "both ways," offense and defense.

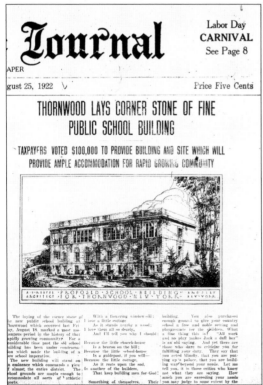

This August 25, 1922, front-page *Pleasantville Journal* report notes that taxpayers voted $100,000 for the construction of Thornwood's first public school building because of a rapidly growing community. The article also states that enough ground was purchased so the country school would have a free and noble setting for playgrounds. "All work and no play makes Jack a dull boy," it reports.

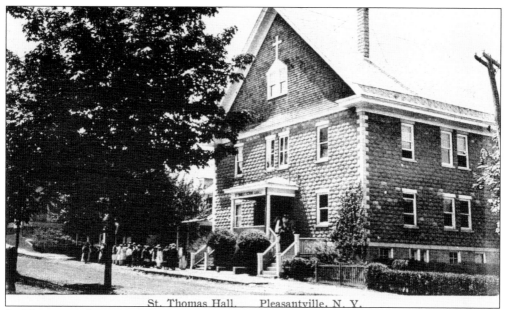

St. Thomas Hall was constructed in the shadows of the old Holy Innocents Church in 1908. It was Mount Pleasant's first parochial school and was located on the corner of Manville Road and Tompkins Avenue in Pleasantville. It consisted of six classrooms, a large hall with a stage, and two bowling alleys. The school was moved to the corner of Orchard Street and Bedford Road (the Girl Scouts building), and the original St. Thomas Hall was torn down. Today it is the parish parking lot.

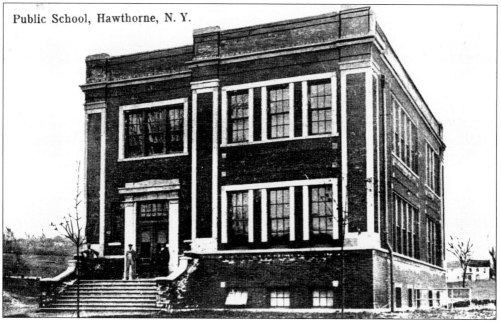

Hawthorne Elementary School was built in 1909 on Broadway across from the Hawthorne Reformed Church. The school contained four large classrooms (two on each floor). The building was used as a school until 1930, when a larger school was built. The building was used by the Mount Pleasant Police Department and town officials until it was torn down in 1975.

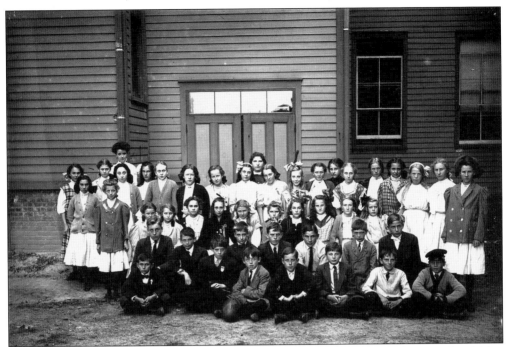

The Bedford Road School included many different grades. This 1905 photograph of Miss Matthew's (tall woman in back) class has twice as many girls as boys. Moreover, the girls feature a wide assortment of fashionable hair ribbons.

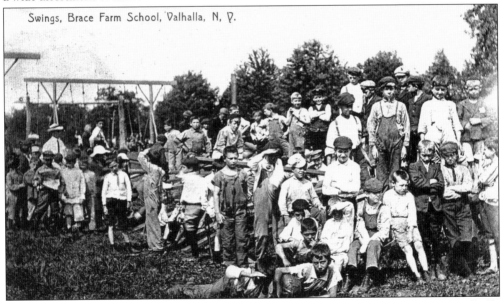

Swings, Brace Farm School, Valhalla, N. Y.

In 1912, the Children's Aid Society of New York City operated an orphanage for boys in Valhalla called the Brace Farm School. Located off Columbus Avenue across from the town hall at the PepsiCo campus, the school taught the boys planting, care and harvesting of crops, the care of farm animals, and the operation and maintenance of farm equipment. There would be as many as 70 boys in the school at one time, as there was a steady rotation as some would enter foster homes when adequate skill levels were attained.

The Harvey School was started in 1916 and located near the former Hawthorne Circle. Dr. Herbert Swift Carter opened the school as an academic institution for the education of his son and other boys who were physically challenged. The school was forced to move to Katonah in 1959 when the State of New York decided to construct a connecting highway interchange on the property.

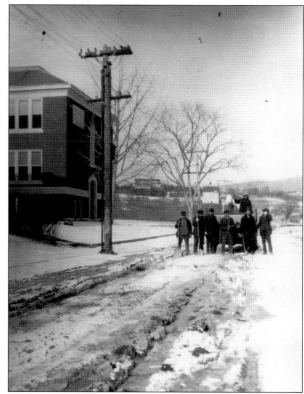

A Pleasantville village snow crew clears a path on Academy Street adjacent to the Bedford Road School. In this 1914 photograph, the Pendleton Dudley farmhouse on Eastview Avenue can be seen in the distant left.

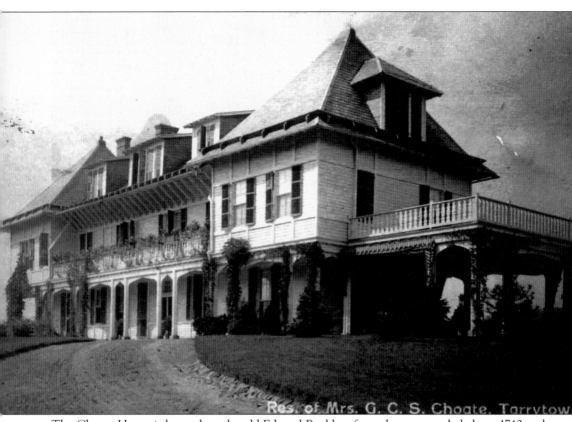

Res. of Mrs. G. C. S. Choate, Tarrytow

The Choate House is located on the old Edward Buckbee farm that was settled about 1740 and later owned by John Roselle, who died in 1838. The Choate House was built in 1867 by shoe manufacturer Samuel Baker. It later became the residence of Dr. George C. S. Choate, who added a wing to the house for his private sanitarium to house wealthy patients being treated for mental and nervous disorders. One of Dr. Choate's most famous patients was the crusading newspaper publisher and politician Horace Greeley. Following his defeat to Gen. Ulysses S. Grant for the GOP nomination for presidency of the United States in 1872, an exhausted Greeley, who had a farm in nearby Chappaqua, checked into Dr. Choate's sanitarium, where he died a few weeks later. In 1909, Dr. Choate's widow, Anne Hyde Clarke, had a wing of the home moved to its present location. The actual job of detaching and moving the original home began on New Year's Day 1909 and lasted until summer. Anne lived there until her death, at age 80, in 1967. Today the Choate House is a vibrant part of the Pleasantville campus of Pace University.

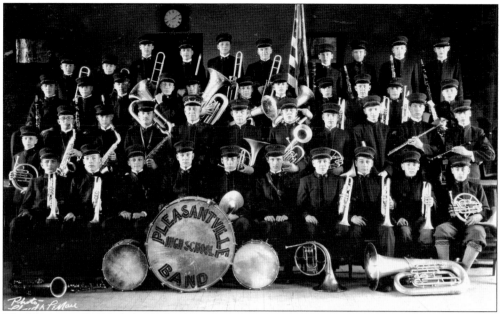

The Pleasantville High School Military Band was founded in 1913 by John E. Morgan and Frederick F. Quinlan, two outstanding educators. It was the first public high school military band in the state of New York. Funding for the band was created by appearances at concerts, parades, and ceremonial functions. In 1935, millionaire resident Hiram Edward Manville started the proud tradition of green and white uniforms when he ordered tailor-made custom uniforms at a cost of nearly $2,500.

The new Pleasantville High School was the pride and joy of principal John E. Morgan. Morgan was central to the success of the educational program in the village. He was also a chapel leader, band director, and teacher, who unfortunately passed away shortly after the doors opened in 1930.

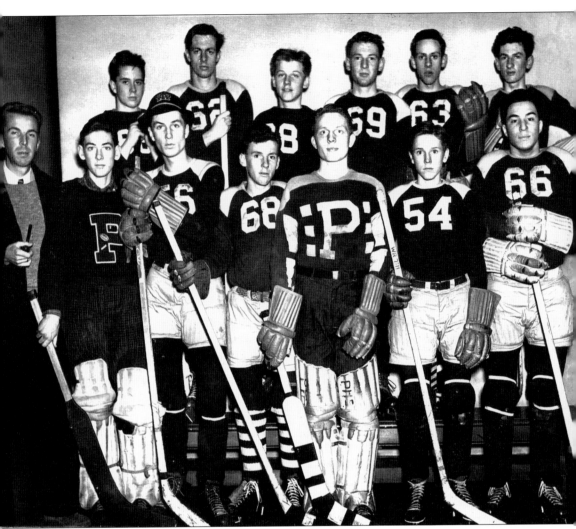

George Gallant (on left with pipe) was born and raised in the northeast hockey territory and never lost his passion for the game. He taught accounting, business administration, and economics in Pleasantville High School and founded the very first school hockey team around 1938. The squad practiced on Opperman's and Munson's Ponds and played games on the ice at Playland. Competition was very tough, and the school only fielded a team for a few years.

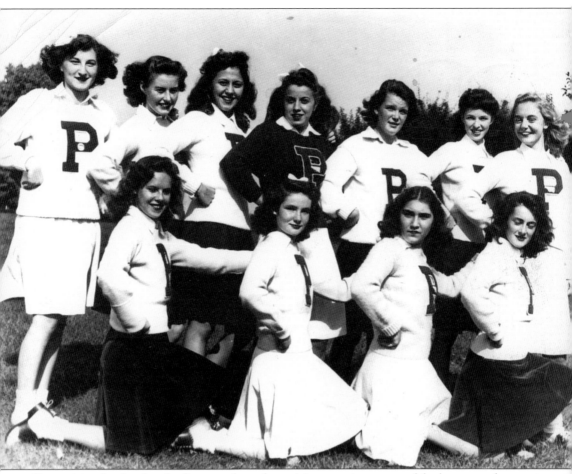

Competition for the cheerleading squad was fierce. Moreover, it was one of the longest and most arduous of sports in the high school. Individual tryouts for the team took place in the school auditorium packed with students under the supervision of Mrs. Reinisch, director of athletics for girls. The captain of the team is in the dark sweater. Ordinarily boys were allowed to compete for membership, but none managed to secure a berth on the 1943 squad seen in this photograph.

The Mount Vernon Wartburg Orphans Farm School was founded in 1866 for needy and homeless children. This 1925 postcard erroneously states that the new development was at Kensico Lake; it was in Valhalla. The school was located on William Hunter's pre–Revolutionary War farm. William Hunter was a Quaker, and his cousin Elijah Hunter was believed to be the original subject of the sensational post–Revolutionary War publication *The Spy*. The property is now the site of the Stonegate homes.

Seven

CHURCHES

Frederick Philipse and his second wife, Catharine Van Cortlandt, built the first church in Mount Pleasant in 1699. It was called the Old Dutch Church and was located in Sleepy Hollow. It was about 150 yards from the manor house. The church was built of similar construction as the manor house except that it had some brick from Holland brought to America as ship ballast. A weather vane still tops the church bearing the Frederick Philipse symbol in the shape of a flag.

The seed of Methodism first came to life in Pleasantville during post–Revolutionary War days. In 1780, class meetings were taking place at Jesse Baker's house, what would become Sen. Seabury Mastick's property on Bear Ridge Road. The meetings were one of the earliest Methodist societies in America. Philip Embury had introduced Methodism into the colonies only 14 to 15 years earlier. From this small nucleus developed the congregation that built the first religious structure in Pleasantville.

In 1818, Henry Clark and his wife, Rachel, conveyed a parcel of land, and a church building was erected that same year. A new church was built in 1852, but heavy ice and snow collapsed the roof in January 1948.

In June 1901, 50-year-old Rose Hawthorne, the daughter of the celebrated writer Nathaniel Hawthorne, moved to Unionville from New York City to purchase an old French Dominican monastery with nine acres that would be called Rosary Hill. Rose was raised in a little red house in Lenox, Massachusetts, that knew the footsteps and presence of American literary legends Ralph Waldo Emerson and Henry Thoreau. However, in 1891, she became a Catholic and started charity work caring for poor incurable cancer patients in New York City. The move to Mount Pleasant would lead to the expansion of that care and the eventual construction of a new building, chapel, and convent from 1927 to 1930.

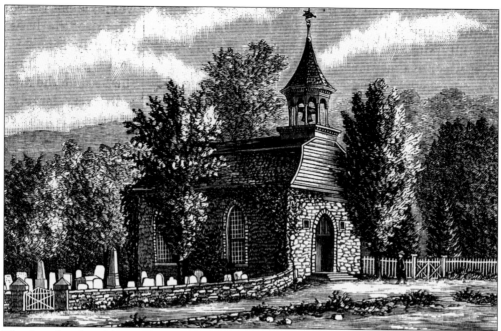

The first church in Mount Pleasant was built in 1699 by Frederick Philipse and his second wife, Catharine Van Cortlandt. Not far from where the church now stands was a chestnut tree sacred to the Weckquaeskeck Indians, who buried their dead within the breath of the branches.

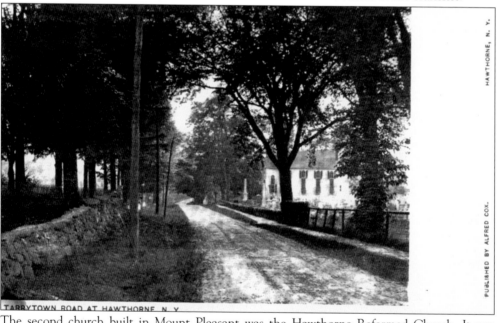

The second church built in Mount Pleasant was the Hawthorne Reformed Church. It was established in 1818 on property acquired from Thomas Hammond (1782–1826) for the amount of $59, and many Revolutionary War dead are buried in the adjoining cemetery. They include Staats Hammond, who served under Gen. George Washington as an orderly and was wounded at the Battle of Trenton. The cemetery also includes Dr. Isaac G. Graham (1760–1848). Dr. Graham was the head physician on General Washington's staff at West Point.

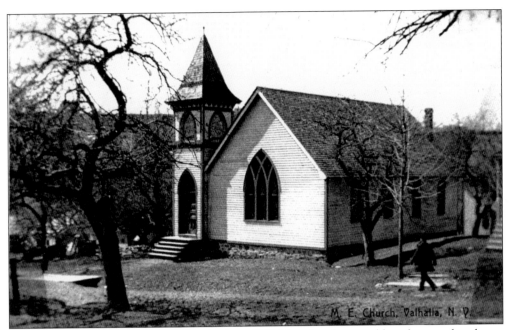

The Methodist church in Kensico was built in 1835. The church was sold, and a new church was built in 1885. Today the site of the church is under the Kensico Reservoir.

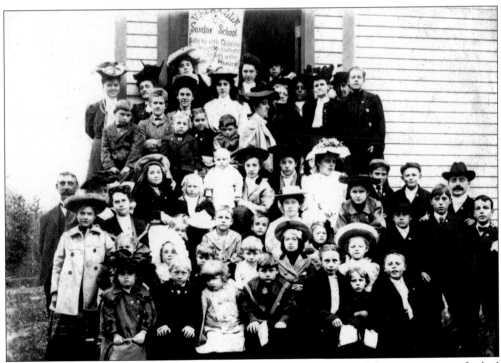

When the Methodist church in Kensico was destroyed, members of the congregation flocked to the chapel in Valhalla on Cleveland Street as a house of worship. This photograph is of the chapel's Sunday school population.

The Methodist congregation grew to the point that this structure was built on Columbus Avenue in 1964. The land for the church was purchased from New York City and is directly across the street from the aerators.

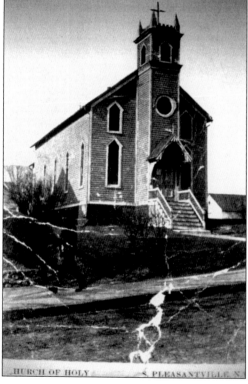

The life of the Catholic Church in Pleasantville started with monthly masses held in Sunset Hall. In 1875, Samuel Schapter, a non-Catholic and husband of Moses Pierce's sister, donated the land for a new church with the condition that it be named Church of the Holy Innocents. The rectory and most of the church were destroyed by fire in February 1912.

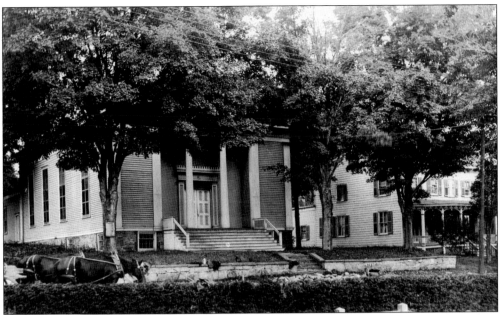

In 1818, the Clark family, after whom Clark's Corners was named before the village was officially called Pleasantville, donated land for the construction of the first Methodist Episcopal church. In 1852, a new church was built on the corner of Broadway and Church Street and the old church was converted into a parsonage and moved across Broadway. The Palmer family was instrumental in the building of the 1852 church. On January 3, 1948, the church in this photograph had its roof collapse under the weight of heavy snow and ice.

St. John's Church was first established in 1853. The congregation built its first church in 1855 and sold it to move into the church in this postcard that was built in 1912. On December 1, 1928, the greatest social event in the history of Mount Pleasant took place here when the former Estelle Romaine Manville married Count Folke Bernadotte of Wisborg, the nephew of King Gustav V of Sweden.

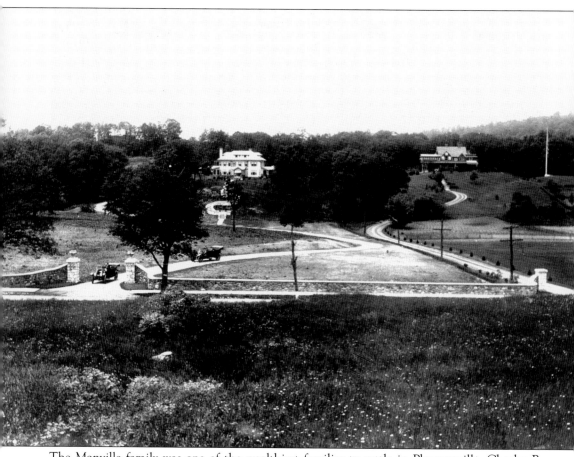

The Manville family was one of the wealthiest families to settle in Pleasantville. Charles B. Manville, cofounder of the Johns-Manville Corporation, purchased 150 acres of farmland from Hanna Pierce in 1908. In 1923, his son Hiram Edward Manville hired renowned architects and designers to erect the 56 rooms and three marble staircases in the Hi-Esmaro mansion. In this photograph, Hiram Edward Manville's mansion has the curved walkway in front, and Charles Manville's home has the long driveway. Tommy Manville, Hiram's brother, was a Manhattan socialite and a popular celebrity in the mid-20th century by virtue of his having married 13 times (to 11 different women). This feat won him an entry in the *Guinness Book of World Records* and made him the subject of jokes by comedians. However, Tommy Manville had the last laugh when it was discovered that there was an oversight in his father's will; he had been left interest from the fortune to live on but could draw $1 million of principal when he married. The will did not stipulate one marriage. The property today is the site of Foxwood.

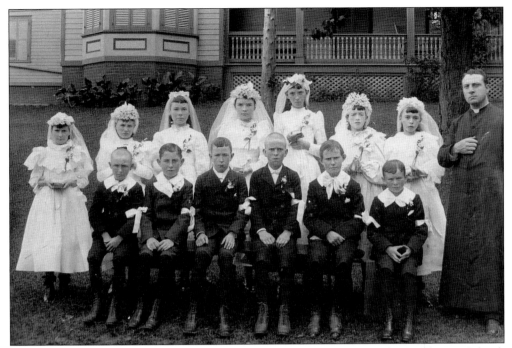

The formal education of Catholic students in Pleasantville took place at the St. Thomas School, which originally operated out of a private home on the east corner of Ashland Avenue and Bedford Road in the late 1890s and into the early 1900s. Earlier gatherings were held in Sunset Hall. (Courtesy of Anne C. Moroney.)

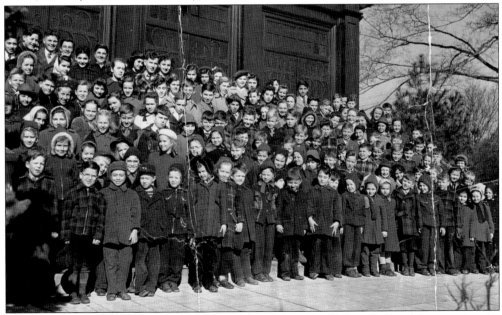

St. Thomas School was on the corner of Tompkins Avenue and Manville Road. It opened at the dawn of the 20th century and was run by Father Regis and Srs. Augustine and Henrietta. The second Holy Innocents Church faced Bedford Road, and the rectory was adjacent to Thomas Hall. In this photograph, bundled students pose for a class picture.

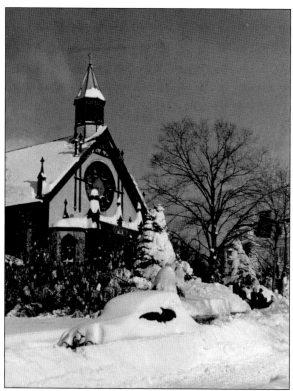

The second Holy Innocents Church in Pleasantville was built in 1913. This photograph was taken after the famous Christmas storm of 1947 that paralyzed the metropolitan area for days. The second church was torn down in 1985 for the construction of a dramatically larger house of worship.

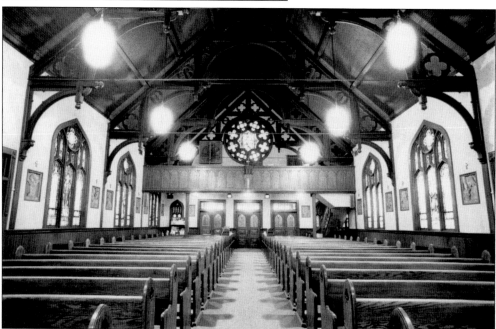

Parishioners of Holy Innocents Church came from all over Mount Pleasant. During the Depression, members of the parish opened their doors to needy children from Catholic Charities in New York City. This photograph captures the solemn dignity of the elegant Pleasantville house of worship.

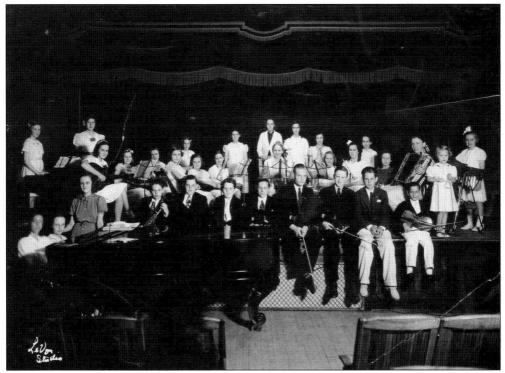

The St. Thomas School Orchestra was the pride of Pleasantville. In this 1928 photograph, the orchestra poses before a formal concert. (Courtesy of Anne C. Moroney.)

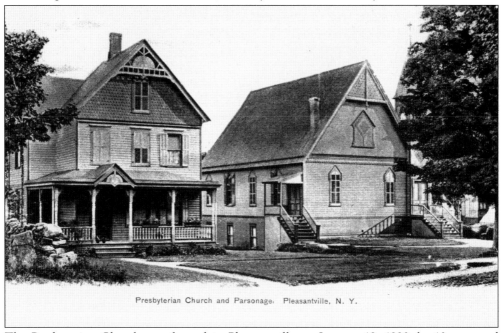

Presbyterian Church and Parsonage. Pleasantville, N. Y.

The Presbyterian Church was formed in Pleasantville on January 18, 1880, by 13 men and women. Prior to that, services were held in Sunset Hall over John Thorn's livery stable on Wheeler Avenue. The church was built on Bedford Road in 1882.

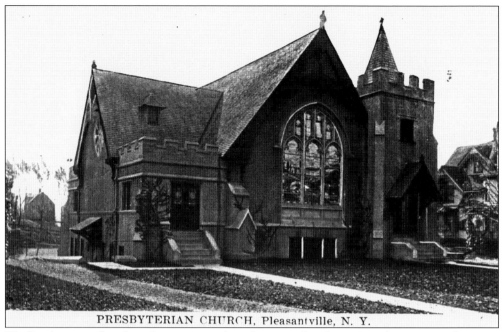

PRESBYTERIAN CHURCH, Pleasantville, N. Y.

The Presbyterian church underwent a number of structural and cosmetic changes over the years. This photograph is from the 1930s.

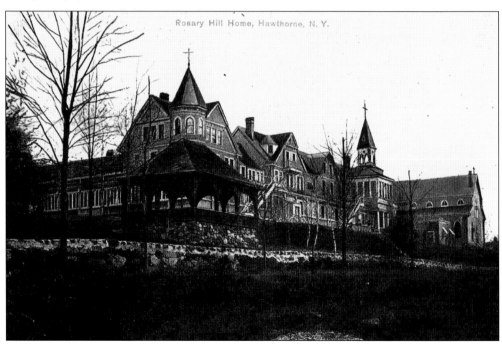

Rosary Hill Home, Hawthorne, N. Y.

Nathaniel Hawthorne's great love of his fellow human beings was perpetuated not only in his immortal writings but in a human apostolate brought into being by his daughter Rose. The "Rose of the Hawthornes," as she was often called, eventually became a member of the Dominican family and dedicated her life to those she felt needed it most—the poor afflicted with incurable cancer. The Rosary Hill Home was the product of her work.

Rose Hawthorne Lathrop.

Rose Hawthorne was the daughter of celebrated American writer Nathaniel Hawthorne. Born on May 20, 1851, in Lenox, Massachusetts, Rose was raised by parents who were dedicated to helping the suffering and distress of the less fortunate. In 1891, Rose was received in the Catholic Church and started working exclusively with the poor.

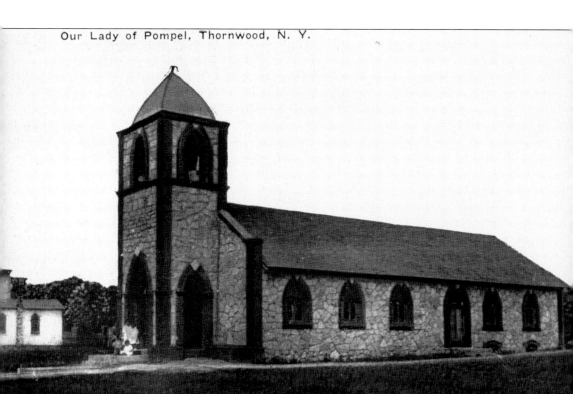

Our Lady of Pompeii Church is a mission of the Holy Innocents Church in Pleasantville built in 1918. It is the only church in Mount Pleasant built by parishioners under the spiritual guidance of Fr. Alexander Mercier, O.P. While in Italy during World War I, he found he could not return to the states because he was not a citizen. He prayed to Our Lady of Pompeii for help and promised to build a chapel in her name if he ever got back to America. Local southern Italian stonecutters, bricklayers, and masons (who had also worked on the Kensico Dam) lived in a small neighborhood that was commonly called "the Flats." The families in the Flats were devoted to Father Mercier and fulfilled his promise.

This photograph is of the many families who built the Our Lady of Pompeii Church on Saratoga Avenue in Pleasantville. Pancrazio Aucello and Salvatore Siciliano supervised the day-to-day construction of the church. The other prominent families that helped build Our Lady of Pompeii included the Cacciola, Camilli, Cangelosi, Cannizzaro, Cedrone, Cioffredi, Cristofalo, Dramas, De Grazia, Gianotto, Gullotta, Molinaro, Napolitano, Pagano, Patane, Raguso, and Reale families. The families built the church for free. Today the church is lovingly cared for as the principal house of worship by many descendants of the original builders. The first baptism on record at the church was of Leonard Pagano. The first marriage was between Charles Raneri and Isabella Adams. The purchase price of the lot on which the church now stands was donated by Rose Hawthorne.

This 1912 photograph is of an era when a casual Sunday during the winter would include driving or even walking across the Hudson River for sport. During the week, trucks and horse-drawn carriages would take advantage of the frozen conditions to conduct regular commerce. (Courtesy of the Westchester County Historical Society.)

Eight

THE WORLD WAR I ERA

World War I did not produce a quick victory as some predicted in 1914. Instead, the trench warfare created an insatiable appetite for men. Early on, Pres. Woodrow Wilson attempted to steer the nation away from war, stating that the United States had no vital stake in the European conflict. In time, the majority of Americans came to believe that Germany and Austria were primarily responsible for the war's outbreak and rooted for an Anglo-French victory. However, the brutal manner in which British military leaders suppressed the Irish Easter Rebellion in Dublin on April 24, 1916, temporarily chilled American political will for joining the war.

Nevertheless, leaders in Washington, D.C., finally concluded that a German victory created too big a threat for America, and as a result the United States entered the war in the spring of 1917. The decision resulted in a massive draft that called up over 1,000 Mount Pleasant men. Germany surrendered in November 1918, but not before an estimated 10 million men lost their lives.

The American Legion was founded by World War I veterans. Interestingly enough, Mount Pleasant veterans were instrumental in the birth of the American Legion. It all started in Paris on March 15–17, 1919, by members of the American Expeditionary Force. They concluded that veterans should band together to lobby the government for the interests of veterans. They held a subsequent meeting in St. Louis on May 9, 1919, to adopt the American Legion as the organization's official name. Then on September 16, 1919, the U.S. Congress officially authorized the charters of the first 100 American Legions in the nation.

The Pleasantville Fancher Nicoll Post 77 is one of the original members of the American Legion in the nation. It is difficult to pinpoint exactly what roles were played; however, records indicate that Bob Clark, the first commander of Post 77; Jim Moroney, the first vice commander; and Seabury Mastick, one of the original Pleasantville members, were the three individuals who took turns attending the critical meetings in Paris, St. Louis, and Washington, D.C.

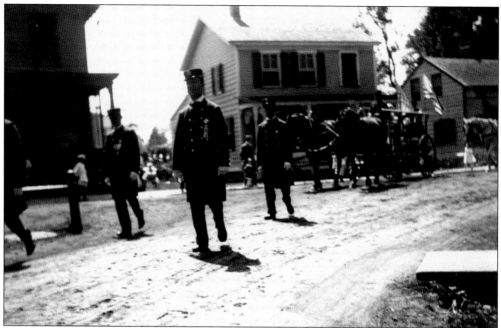

The Pleasantville Pioneer Engine Company was organized on December 10, 1894. It has a proud tradition of service in Mount Pleasant and has the oldest marching band in the state. During World War I, Pioneer had a roster of 30 men; 14 immediately answered the nation's call to duty. In this 1900 photograph is horse-drawn equipment purchased in 1894 at a cost of $700. It was the only pumping apparatus between White Plains and Mount Kisco. It pumped 250 gallons of water a minute with two men pumping on each side.

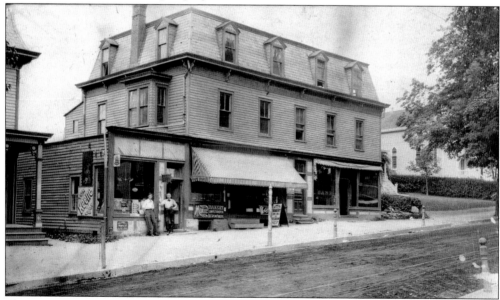

The Bogen Building in Pleasantville would go on to be Cadman's Pharmacy. However, in this 1904 photograph the original Mount Pleasant Bank and Trust Company is open for business. To the right of the bank is the original Holy Innocents Church. On the other side of the bank is Reynolds Bakery, confectionery, and ice-cream parlor and then Gibson's five-and-dime store.

The Pleasantville Masonic Lodge was instituted in July 1910 and received its charter in 1911, with a membership of 51. On January 6, 1921, it bought the Guion property on depot square (Memorial Plaza) to build the community house. The beautiful structure burned down a few years afterward.

TO COMMEMORATE
THE FORMAL OPENING OF
THE PLEASANTVILLE
COMMUNITY HOUSE

PLEASANTVILLE, N. Y.
MARCH 20TH 1922

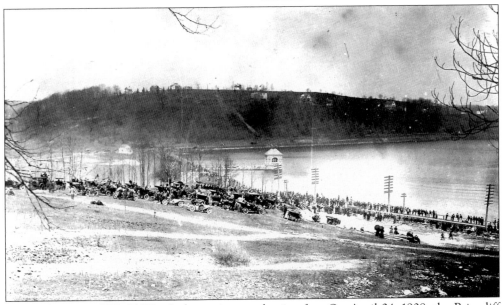

Before the start of World War I, the nation was having fun. On April 24, 1908, the Briarcliff International Automobile Race was the first stock car race in America. Twenty-two cars entered in the competition. Eleven cars were American, six cars were Italian, three cars were French, and there was one car from both Austria and Germany. Some of the cars were sponsored by corporations while others were owned by wealthy individuals. Over 300,000 people watched the race along its route, thousands of whom walked from White Plains to view sports at Eastview and Kensico. This photograph was taken at the earthen dam in Kensico. (Courtesy of the Westchester County Historical Society.)

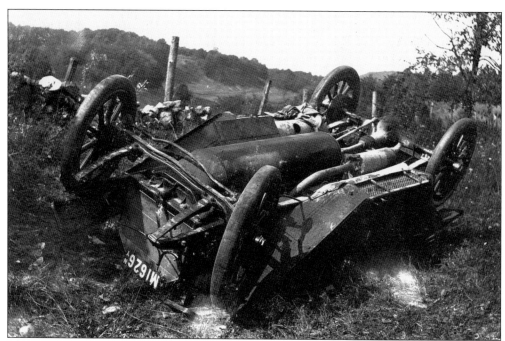

The experienced American and European drivers said the race circuit was one of the roughest and most perilous on which a road race had ever been held. The course included hills, sharp turns, narrow stretches, and hazardous road conditions. Drivers averaged an estimated 40 to 45 miles per hour. However, on a straight section of road leading from Mount Kisco to Armonk (called Bishop's Flat), cars attained a high speed of 70 miles per hour. The race was won by Italian Louis Strang, racing in an Italian-made Isotta-Franschini, in 5 hours, 14 minutes, and 13 seconds. This photograph is of another car that failed to properly negotiate the conditions of the road.

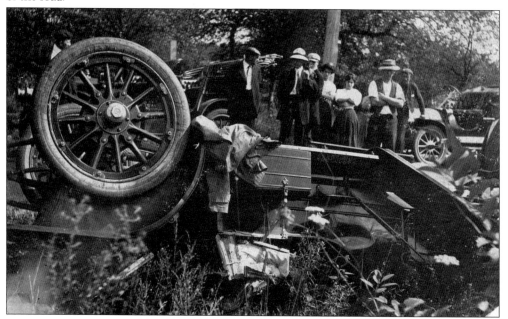

The Pleasantville Fire Department is seen in the 1914 Memorial Day parade. This photograph was taken on lower Bedford Road just before the doorstep of the present-day Foley's Club Lounge. In the front row, second from right, is Archer Guion, a prominent member of the Pleasantville community.

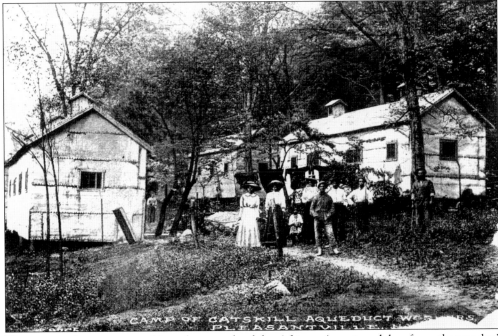

This extremely rare postcard is a photograph of the African American labor force that worked on the Catskill Aqueduct. They often could not afford or were not encouraged to live in towns. Consequently, contractors working exclusively for the New York City Board of Water Supply would construct temporary housing outside population centers for the African American workers and their families. This 1915 photograph is of the African American community temporary housing in Pleasantville.

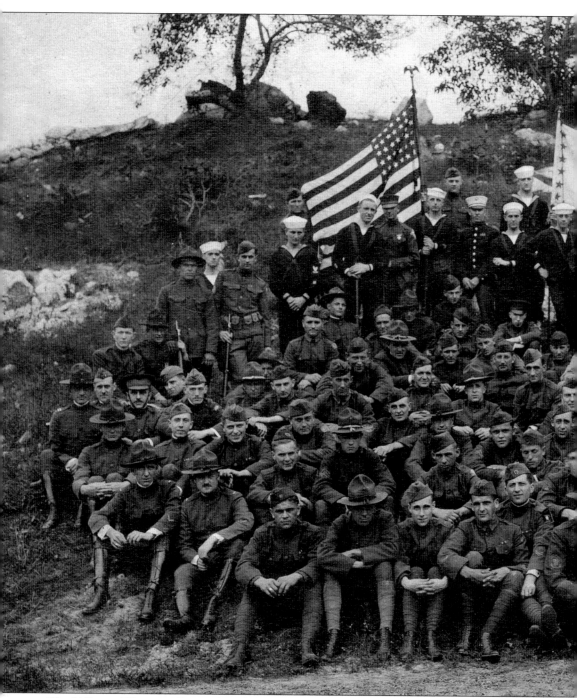

The Village of Pleasantville purchased three acres of land at a cost of $6,000 for a World War I memorial. This photograph is of the gathering of the Pleasantville Fancher Nicoll American Legion Post 77. The field would eventually have a baseball field, grandstand, dancing pavilion, and frame building used by the Girl Scouts all for the cost of $2,000. Bob Clark, the first commander of the post, is seated in the first row (with his arms wrapped around one knee, next to the doughboy with his arms wrapped around both knees and in between the two marines

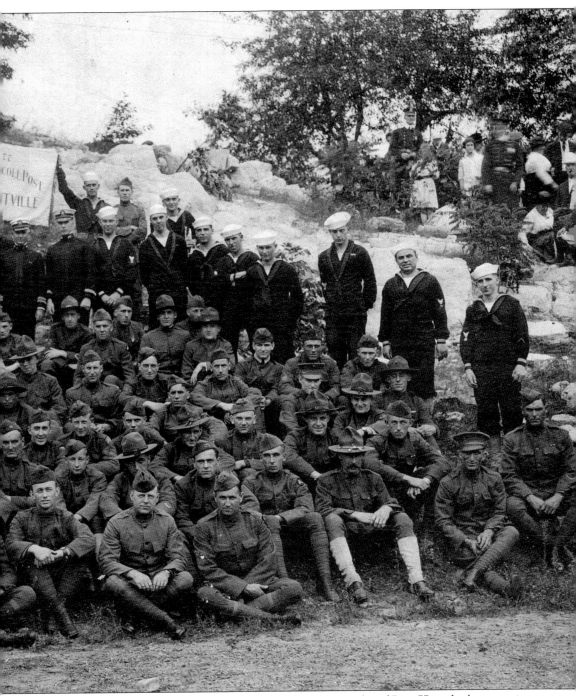

with the wide brim hats). Jim Moroney, the first vice commander of Post 77, is the last man in the first row to the right of Clark. And Seabury Mastick is the older gentleman front and center in the last row below the Fancher Nicoll flag with his arms at his sides and his white naval officer's cap. Clark, Moroney, and Mastick were among the original small core of veterans in the entire nation that started the American Legion in the United States.

In November 1901, 14 residents of the old village petitioned the commissioners of the Pleasantville Fire Department for consent to organize a hose company. On December 2, the petition was granted and the name Daniel P. Hays Hose Company was chosen. Decades later the company showed off its modern motorized equipment.

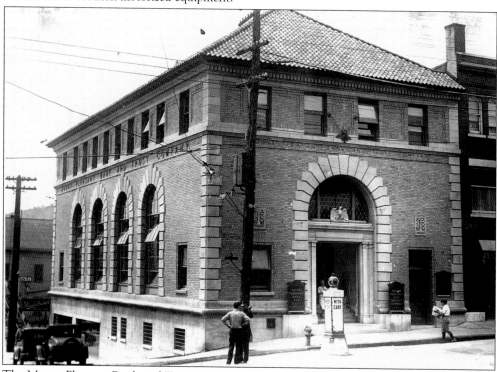

The Mount Pleasant Bank and Trust Company opened for business in Pleasantville on April 6, 1904. It was the first bank in town and rented space in the building that went on to be Cadman's Drug Store on Bedford Road for $10 a month.

In 1930, the icebox was an essential feature of the modern kitchen. In this photograph, owner James J. Moroney proudly displays his collection of iceboxes and gas stoves at his 13 Wheeler Avenue, Pleasantville, store. (Courtesy of Anne C. Moroney.)

In this 1929 photograph, Evelyn Smith (shaking hands) of Yorktown presents a gigantic spruce tree located on her property to the Fancher Nicoll American Legion Post of Pleasantville. The Yorktown American Legion facilitated the transfer. (Courtesy of Louise Perez.)

R. B. Henry Milk Company opened to business on Columbus Avenue in Valhalla in the early 1930s. It was a family business. Upon R. B. Henry's death, his three sons , Raymond, Robert, and Clifford, assumed control of day-to-day responsibilities. The R. B. Henry Milk Company closed its doors for business in 1984.

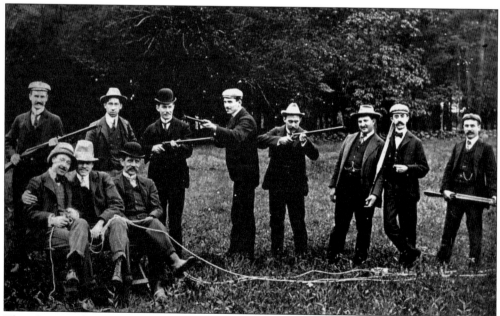

This photograph is of the Mount Pleasant Gun Club around 1890. There are no official records in the Mount Pleasant Historical Society of the gun club. However, there are accounts of its existence.

In this 1929 photograph, Evelyn Smith (in fur coat) presides at the official planting of the gigantic spruce tree on Manville Road with members of the Pleasantville and Yorktown American Legion. Willow Street is off to the left behind New York State senator Seabury Mastick (with Legion cap and glasses). (Courtesy of Louise Perez.)

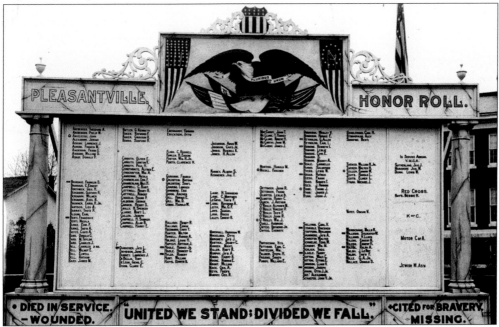

In 1927, a committee was formed to gather the names of all who served honorably in World War I. Bert Carmer, president of the Mount Pleasant Bank, and James J. Moroney, a local businessman, chaired the committee and took responsibility for funding the project. Moroney initiated the funding with $200 from the American Legion Post 77 (a considerable amount considering a new car cost $600). It took two years to compile the names and secure the funding. The plaque was cast in a New York City foundry. In 1970, it was set in light Vermont granite mined and shaped in Barre, Vermont.

Pancrazio Aucello and Salvatore Siciliano would build several important Pleasantville landmarks, including the old Rome Theatre. This 1927 photograph is the present Holmes and Kennedy Real Estate offices.

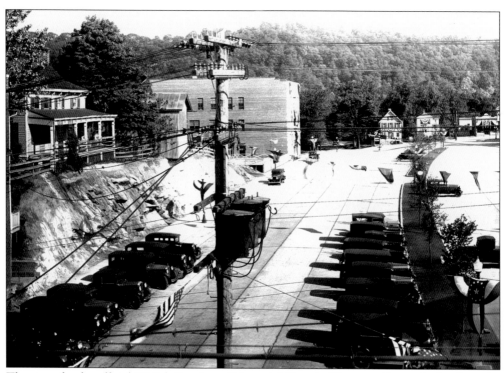

The stage for the official 1930 dedication of Memorial Plaza in Pleasantville was built where the post office sits today next to the original Cornell Building.

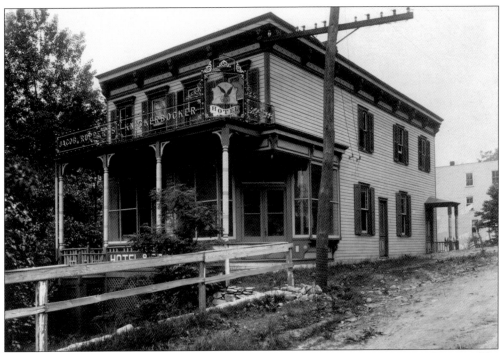

The Valhalla Hotel advertised Jacob Rupperts Knickerbocker lager beer. The hotel was used by visitors as a resting stop before getting back on the train the following day and continuing on the journey north.

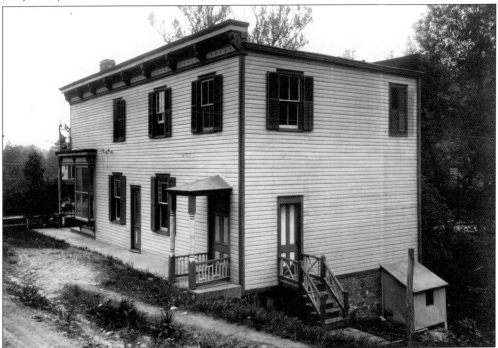

The front of the Valhalla Hotel accessed the front desk and bar. The side entrance was used for access to rooms. The rear door was used exclusively by the hotel service workers.

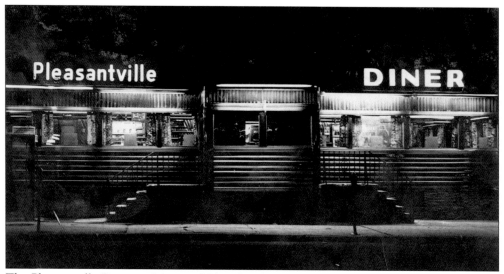

The Pleasantville Diner on Memorial Plaza has been a popular family meeting place for over half a century. This 1955 evening photograph is complete with inviting bright lights. (Courtesy of Jack Mourouzis.)

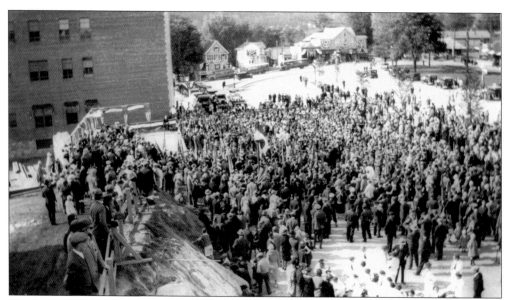

The June 1930 Memorial Day ceremony was attended by thousands. Note the buses at the far end of the plaza and the original Masonic temple with no buses in front of it.

The holiday Christmas tree on Memorial Plaza in Pleasantville is seen in December 1935. Note that the post office has not been built yet, but the Pleasantville Diner now sits next to the original Cornell Building.

This photograph is of the blue-ribbon guests attending the official 1930 Memorial Plaza dedication. From left to right are (first row) ex-congressman John R. Farr of Scranton, Pennsylvania; Lt. Comdr. Paul E. Duban, naval attaché, French embassy, Washington, D.C.; Maj. Gen. John F. O'Ryan of New York; and New York State senator Seabury Mastick; (second row) Robert J. Williams; B. Ray Keefer; John W. Front; Comdr. Samuel Goldstein; B. H. Krey; John A. McEveety; John Farr Jr.; and Judge Spencer A. Studwell. The photograph was taken at Senator Mastick's Bear Ridge Road farm.

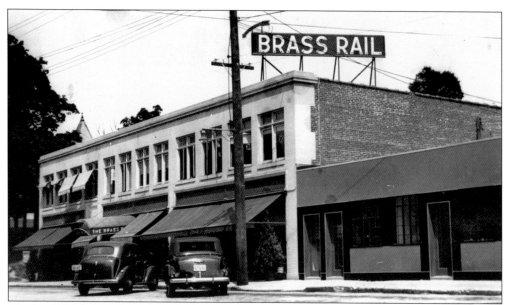

The Brass Rail was a popular nightclub. It opened on March 1, 1933, when Prohibition ended. Patrons reportedly would take the train from as far as New York City. The Brass Rail featured a large circular bar with a raised piano in the middle. In 1960, Harry Foley bought the club and moved it across the street to where McArthur's American Grill is today.

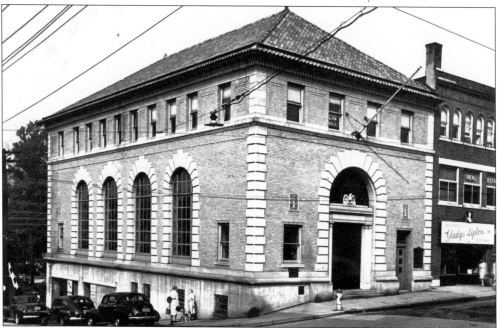

After training in New York City under a program sponsored by the YWCA and the Department of Labor, Lila Acheson vacationed in Pleasantville in the summer of 1920. She loved the village and returned to Pleasantville the following year to marry DeWitt Wallace in the Presbyterian church. The couple returned to New York City and launched *Reader's Digest* in a basement below a Greenwich Village speakeasy in 1922. In 1936, with circulation nearing two million, *Reader's Digest* rented the top floor of the Mount Pleasant Bank for the 32 members of the editorial staff.

The Mount Pleasant Ice Cream Company was founded by James Bard in 1923 and was located on Edgewood Avenue in Thornwood. This 1937 photograph with the "Mount Pleasant Ice Cream" sign was taken in front of the Pancrazio Aucello Grocery Store on Saratoga Avenue in Pleasantville. The two boys in the photograph are Sal Rubino and Ben Berte (with hand on sign). (Courtesy of Grace D. Baer.)

Saks Department Store (no relation to Fifth Avenue) was a family-run store that opened for business in the mid-1920s. The store sold dry goods, shoes, apparel, and furnishings. Mr. Saks owned the building and lived on the third floor with his family. The second floor was rented to the telephone company, which employed teams of operators to connect all local, long-distance, and international calls. The Saks family maintained the business into the 1970s.

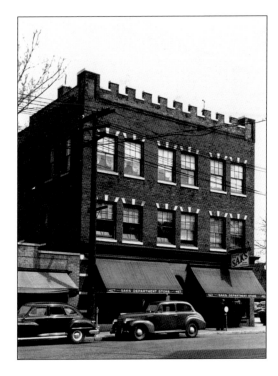

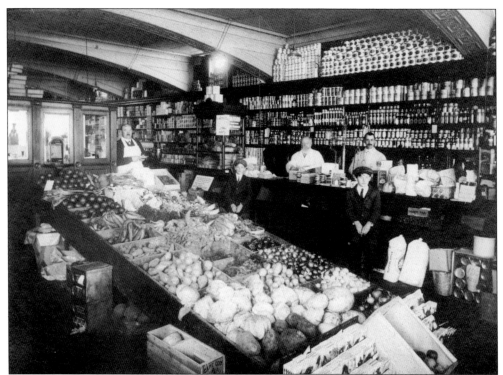

Koster's Market in Pleasantville was well supplied with fresh bread, meat, produce, and an extensive array of canned and bottled goods. This 1915 photograph of a spotless store, neatly stacked cans, two counter clerks, two delivery boys, and a butcher was used to advertise Koster's inventory and service.

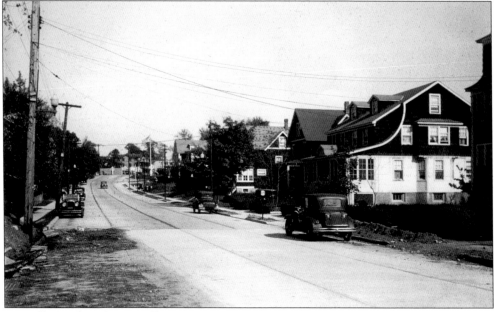

Manville Road in Pleasantville was a major artery before the construction of the Saw Mill River Parkway. This 1932 photograph is looking east toward the railroad station.

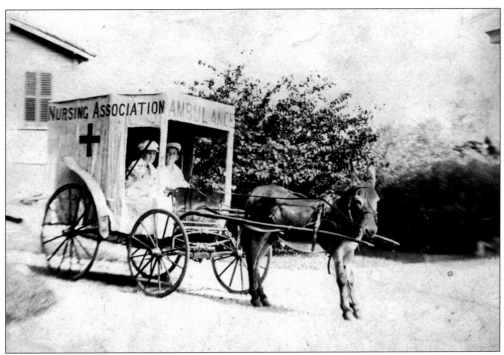

The Red Cross was a large organization with deep roots in Mount Pleasant. So much so that it boasted this 1910 small ambulance driven by Pleasantville youngsters Ken Jones and Ernie Wilcox.

The Rome Theatre in Pleasantville was built in 1925. The Spanish mission–style landmark was one of the first movie theaters in Westchester County. It closed its doors for business in 1985 but reopened nearly 15 years later when the Jacob Burns Film Center revolutionized the industry with a diverse program of classic, foreign, modern, scholarly, human rights, and private screening films.

This December 19, 1937, photograph is of early-morning skating on a frozen Soldiers and Sailors Field. Every winter the Pleasantville Fancher Nicoll American Legion Post No. 77 would routinely build a simple one-foot dirt wall around the area and flood it. Manville Road is on the far side of this photograph.

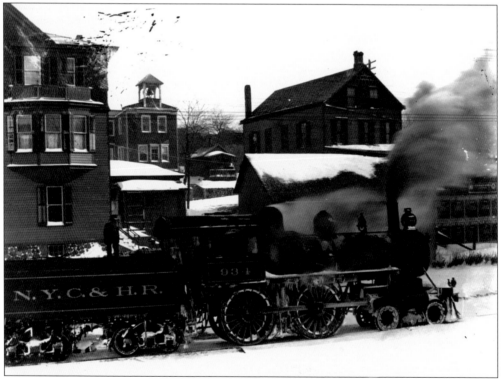

The southbound New York Central and Harlem Railroad is waiting by Wheeler Avenue in Pleasantville for passengers and cargo to load at the station. Note the firehouse with the bell tower in the background.

Nine

THE WORLD WAR II ERA

There are many chronicles of Mount Pleasant during World War II. Pleasantville and other communities had hundreds of civilian airplane spotters who would be called the Air Raid Warning Service. In Pleasantville, for instance, the spotters took shifts in the high school observation tower. High school students would watch at 6:00 in the morning until classes started, when they would be replaced by housewives who carried on through the day until the men took over at 6:00 in the evening.

The war on the home front also produced thousands of victory gardens. Moreover, high school girls were called on to tend babies so mothers could work in war plants. The Red Cross formed production committees, where women would stay busy making surgical dressings, garments, and other articles needed by hospitals. There were also auxiliary policemen who patrolled waterworks and other strategic spots after dark. Not to be overlooked were the regular war bond drives and collections for the Red Cross and USO. Residents of Mount Pleasant, like all Americans across the nation, also learned how to live with the directives of the ration board that created limitations on gas, oil, tires, shoes, meat, coffee, and sugar.

Another unusual story of World War II is that of Chips, an army K-9 corps dog born and raised in Pleasantville. Chips, a mixture of shepherd, collie, and husky, was raised by Mr. and Mrs. Edward Wren and their two daughters, Gail, age 9, and Nancy, age 6, at 26 Orchard Street and became the first canine in the history of the United States to receive the Distinguished Service Cross for heroism on the field of battle. The war department explained that it was contrary to traditions of the service to award medals to animals. However, when the three-year-old Chips facilitated in the capture of 12 Italian soldiers in the Sicilian campaign and then went on to silence a Nazi operating a machine gun nest at the risk of his life, the army made an exception. During the course of his career, Chips met Pres. Franklin D. Roosevelt, Prime Minister Winston Churchill, and Gen. Dwight Eisenhower.

Glories of 'Sunset Hall' Recalled As Thorn Building Faces Demolition

One of the last reminders of Pleasantville as it was before the turn of the century today is awaiting the blow of the wrecker's hammer.

The Thorn Building on Wheeler Avenue once better known as "Sunset Hall," which was taken over by the Federal Deposit Insurance Corporation during the financial reorganization of the Mount Pleasant Bank, will be torn down this week, it was learned today.

Before the turn of the century "Sunset Hall" was Pleasantville's community center and the scene of all public entertainment in this village. Swiss bell ringers, Venetian glass blowers, traveling comedians and circuses once strolled its stage while another generation of Pleasantville citizens laughed and applauded.

The building was built about 75 years ago by John I. Thorn and was originally located just south of its present site. It was moved to its present location about 1904, around which time it was replaced as a community center by the "new" fire headquarters which were built opposite the present Municipal Building. Several years later community activities again shifted to the Community Hall located at the corner of what is now Wheeler Avenue and Bedford Road. Both of these latter buildings were torn down during the past four years.

The corner stone of "Sunset Hall", inscribed with the name of John I. Thorn can still be seen on the present building, but will serve to remind only a few "old timers" of the gas-lit merriment that once graced its halls.

May 22, 1941

After over 100 years of service in Pleasantville, Sunset Hall (looming in rear) was condemned for demolition. This May 23, 1941, photograph was taken one week before demolition was to start.

With the demolition of Sunset Hall, a long history of political debates, community meetings, faith-based gatherings, and wonderful nights of entertainment would come to an end. This 1894 ticket stub is of the second annual entertainment given by the Perseverance Council at Sunset Hall. Price of admission was 25¢.

Edmund J. Anderson was born on May 12, 1883, the eighth child and fourth son of an estate superintendent in Kensico. In 1919, he bought a butcher store in Pleasantville and for many years organized the local Halloween parade. During World War II, he published a one-page monthly newsletter called *Mail Bag* combining jokes and local news in equal parts to some 100 servicemen and servicewomen around the world as well as to about 700 other subscribers. In this photograph, a young "Uncle Ed" Anderson (center) practices his trade.

The Valhalla Fire Department marches in the 1940 Memorial Day parade on Main Street past the Atlantic and Pacific Tea Company store in Valhalla.

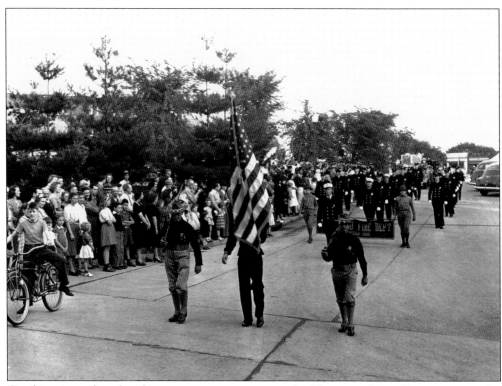

Combinations of aged and very young men represent the Thornwood Fire Department in the 1942 Pleasantvill Memorial Day parade.

With the drums of war calling young men and women into the military, the Hawthorne Fire Department Women's Auxiliary marches in the 1942 Pleasantville Memorial Day parade.

The draft and heavy enlistment reduced the ranks of able-bodied men. In this photograph, the Briarcliff Manor Fire Department Women's Auxiliary also marches in the 1942 Pleasantville Memorial Day parade.

By July 1942, Abby H. Lee (wife of Joseph Lee) of Mountain Road in Pleasantville had four sons in the armed forces during World War II. The local newspaper the *Townsman* speculated she was the first mother in the nation to have four sons in uniform. In this photograph she reads to her many grandchildren. Her oldest son, Lt. Col. Joseph Day Lee Jr., age 33, was in charge of the fighter command school in Orlando, Florida. Howell Lee, age 30, was a lieutenant in engineer school at Fort George Wright in Spokane, Washington. John Barnsdall Lee, age 27, was a second lieutenant at engineer training school at Fort Belvoir. The youngest son, Philip A. Lee, age 22, a recent graduate of Dartmouth College, was at Fort Dix awaiting transit to the Army Air Corps. Ultimately, Philip was the only son who made the ultimate sacrifice for his nation and would not return to his family in Pleasantville.

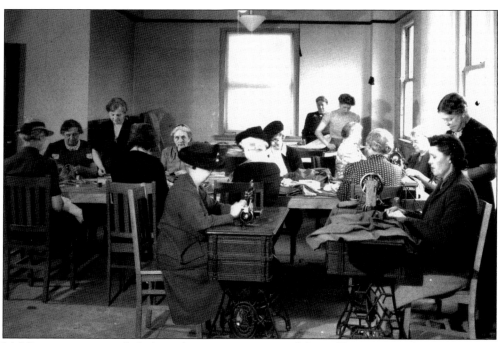

Middle-age women regularly formed sewing groups across Mount Pleasant to prepare garments or bandages to support the war effort. This 1943 sewing group would meet regularly in Pleasantville.

275577 CT

UNITED STATES OF AMERICA
OFFICE OF PRICE ADMINISTRATION

WAR RATION BOOK FOUR

Issued to *Abby H. Lee*
(Print first, middle, and last names)

Complete address *220 Mountain Rd.*

Pleasantville, New York

READ BEFORE SIGNING

In accepting this book, I recognize that it remains the property of the United States Government. I will use it only in the manner and for the purposes authorized by the Office of Price Administration.

Void if Altered

(Signature)

It is a criminal offense to violate rationing regulations.

OPA Form R-145 16— 35570–1

Having four sons in uniform won her no concessions. Here is Abby H. Lee's United States of America Office of Price Administration war ration book.

This August 17, 1940, photograph is of a New York State Police investigation of an airplane crash at Reynolds Field. The damage to the airplane appears minimal, despite landing without the assistance of landing gear (wheels). Eventually the field was called the Reynolds Central Westchester Airport and approimately 289 members flew there. The U.S. Department of Commerce ordered the field closed during World War II.

Shortly after the United States Department of Commerce ordered Reynolds Field in Valhalla closed during World War II, local stock car enthusiasts organized highly popular and extremely dangerous "second-gear only" races.

Chips, an army K-9 corps dog born and raised in Pleasantville, was the first canine to receive the Distinguished Service Cross for heroism on the field of battle. During the course of his World War II military career, Chips met Pres. Franklin D. Roosevelt, Prime Minister Winston Churchill, and Gen. Dwight Eisenhower.

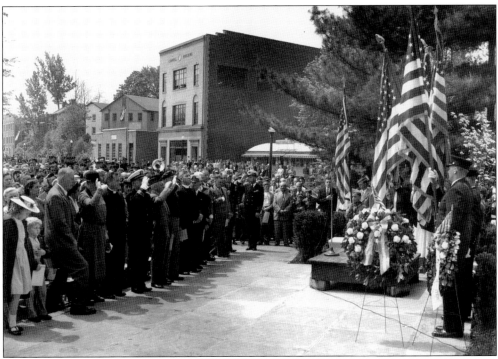

Thousands of spectators filled Memorial Plaza on May 30, 1950, for the World War II memorial dedication.

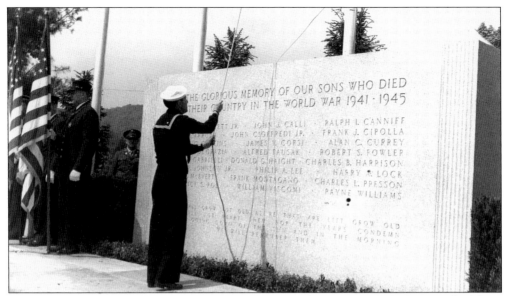

The May 30, 1950, Memorial Day dedication in Pleasantville is seen with the honor roll of those who died in the service of their nation in World War II. Note Philip A. Lee's name, center row, third from bottom.

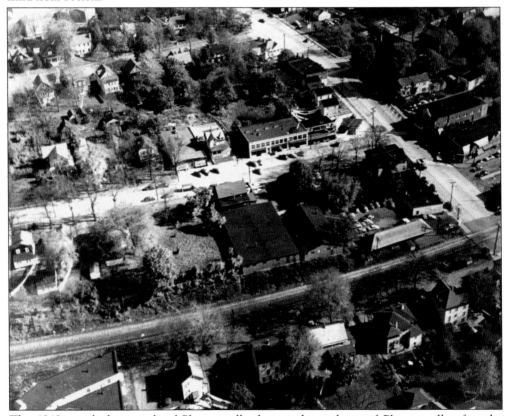

The 1948 aerial photograph of Pleasantville depicts the makeup of Pleasantville after the conclusion of World War II.

Ten

THE SUBURBS

Mount Pleasant was incorporated in 1788. However, it has managed to preserve much of its natural beauty and today is commonly called a bedroom community of New York City. In 1790, the county of Westchester census reported a population of 1,921. The population today is 43,221, according to a recent census. Certainly, the arrival of the New York Central and Harlem Railroad and the construction of the Bronx River and Saw Mill River Parkways nurtured the growth of Mount Pleasant. However, the prudent management of civic affairs by elected officials, the strong tradition of excellence by education administrators, and the gifting of vast land holdings by the Rockefeller family have made Mount Pleasant an attractive community in which to raise a family.

To this end, many great Americans have called Mount Pleasant home. Some gained fame in politics or the bright lights of Broadway. Others accumulated wealth on Wall Street or made great advances in medicine, science, or the arts. Some were blessed with powerful families. While others became successful with good decisions, an earnest work ethic, and good old-fashioned luck. One such individual stands out; his name is Richard (Rick) McCoy. He came from a middle-class family that lost everything in the Depression. He was a gifted baseball player and to his own admission was not a very good student who dropped out of Columbia University to strike out on his own.

After leaving Pleasantville, McCoy went on to become the largest McDonald's franchisee in the United States with over 100 locations. In doing so, he became a multimillionaire with most of his wealth coming from McDonald's, real estate, and banking. At one time, he negotiated with the Yawkey family to buy the Boston Red Sox but stepped aside when John Henry raised the stakes. McCoy and his wife, Jan, have been frequent guests in the White House and have been critical to the growth of Ronald McDonald House Charities. Still and all, what makes Rick McCoy truly special is his uncharacteristic modesty and his uncanny ability to never forget his childhood friends or his Mount Pleasant roots.

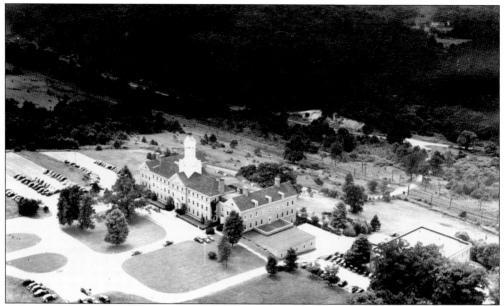

In 1936, the *Reader's Digest* had overflowed its original garage and pony shed of owners DeWitt and Lila Wallace and expanded to 14 separate and crowded offices in Pleasantville. The Wallaces wanted to stay in Pleasantville, but the village had little land. Consequently, they bought over 100 acres of wooded land on rolling hills in Chappaqua. In 1939, they completed the building of the white-towered, three-story, redbrick Georgian structure with 185,000 cubic feet of working space.

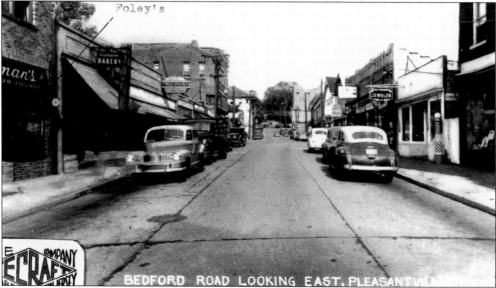

This 1948 photograph is of Foley's on Bedford Road looking east in Pleasantville. Harry Foley was a Pleasantville High School basketball legend. He was also a Niagara University Hall of Fame and Westchester County Hall of Fame athlete. He bought Gorman's Club Lounge on Bedford Road in 1950 and maintained the establishment until the 1970s. Foley's Club Lounge has been a traditional watering hole for generations of Pace University students for nearly a half century.

Wheeler Avenue is seen in 1950 with Lipton's Super Market, which was a mainstay in Pleasantville. It moved from Wheeler Avenue to Washington Avenue in the 1960s. The 1888 Huff Hotel with its two-tier porch is in the background. The Huff Hotel was torn down the following year.

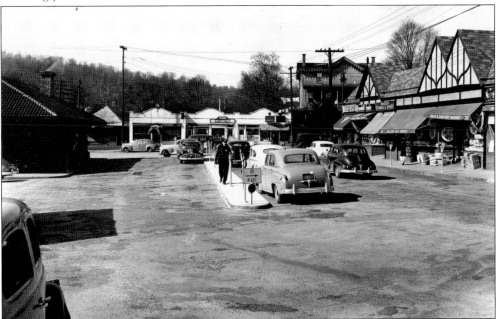

The Pleasantville train station is on the left. Behind it is the freight station. On Manville Road (the white building) from left to right are the Fireside Bar, Plaza Auto Electric, the barbershop, Kings Crown Liquor, and the Huff Hotel. Wheeler Avenue became a one-way street in the early 1980s.

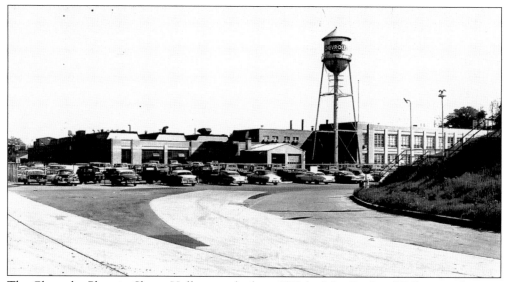

The Chevrolet Plant in Sleepy Hollow was built in 1899 by John Brisben Walker on what was known as Kingland Point to build steam automobiles. In 1904, the Maxwell Briscoe Motor Company bought the plant and employed 2,000 workers. However, in 1915, Chevrolet took over production. This giant factory was bordered by the New York Central Railroad on one side and the Hudson River on the other. The cars that were manufactured by Chevrolet were shipped across the nation by railroad, water, and on large trucks. Chevrolet produced 125,000 cars a year and employed approximately 3,200 assembly workers. (Courtesy of the Westchester County Historical Society.)

In 1943, the General Motors assembly plant in Sleepy Hollow was converted to make parts for the Avenger torpedo bomber plane during World War II. With a dearth of a strong male workforce, young physically fit women conquered the many demanding jobs inside the assembly plant. (Courtesy of the Westchester County Historical Society.)

The Saw Mill River Parkway southbound provided an easy 30-mile drive to New York City. Northbound, it connected Mount Pleasant to northern Westchester County.

Season's
Greetings

Franzl Vogl and Family

Franzl's German Restaurant in Valhalla opened its doors in the late 1940s and was a popular nightspot for decades. Entertainment was generally a skilled accordionist, with the highlight of the evening being Franzl coming out to surprise all with his musical play of an old-country saw.

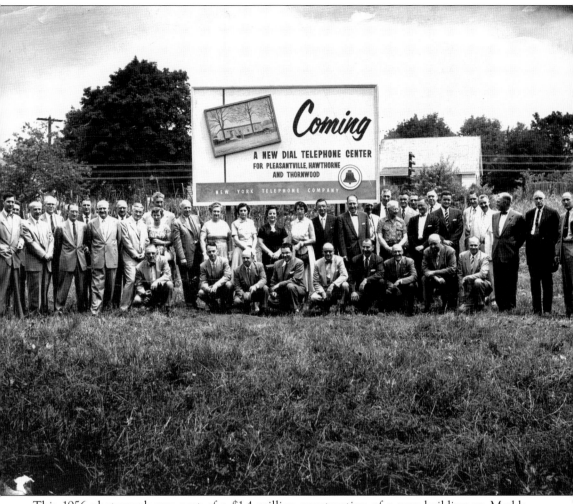

This 1956 photograph was part of a $1.4 million construction of a new building on Marble Avenue in Pleasantville for the installation of modern dialing equipment. It was replacing the second-floor team of operators at 465 Bedford Road over Saks Department Store. Pleasantville's first telephone was installed in Huff Hotel on Manville Road in 1895.

This February 15, 1968, photograph is of student Philip Field Horne holding an old railroad track crossing guard stop sign. In 1971, Horne, a junior at Williams College in Massachusetts, published *Mount Pleasant: The History of a New York Suburb and Its People*. Horne was a resident of Hawthorne, and his publication has yet to be surpassed academically and is the comprehensive authority on the history of Mount Pleasant from 1680 to 1970.

The small Lake Street Pond would be the first body of water to freeze in the winter and was often crowded with ice-skaters. However, during the heavy rains of spring the pond would often overflow down Lake Street. This construction would resolve the issue permanently.

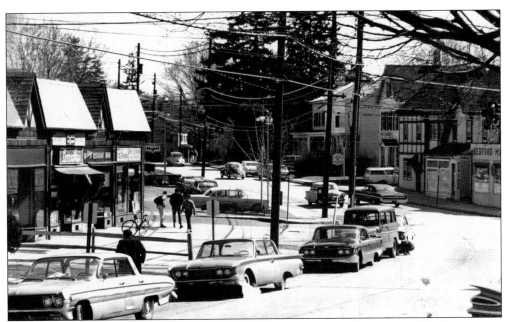

This area was originally called Clark's Corners by early settlers and then the Old Village when Pleasantville was selected as the official name of the village in 1828.

The World War II memorial dedication took place at the Our Lady of Pompeii Church in the Flats neighborhood of Pleasantville. From left to right are Michael Aucello, Michael De Grazia, Jimmy Caruso, Rosaria Rubino, and Tony Ariston. The plaque reads, "In Honor of the Men and Women of this Community Who Served in the Armed Forces of the United States in World War II." John Cioffredi Jr., Frank J. Cipolla, and Albert P. De Grazia all grew up in the Flats and perished in the war.

125

Ye Olde Tyme Minstrel

Presented by

Pleasantville Lions Club
CHARITY FUND

High School Auditorium November 1, 1946

The Pleasantville Lions Club was a vibrant part of the community. "Ye Olde Tyme Minstrel" was an highly popular annual musical production that attracted crowds from all over Mount Pleasant.

Pleasantville native Rick McCoy would become the largest McDonald's franchisee in the United States. In this official White House photograph, he meets with Pres. George Herbert Walker Bush. The president signed the photograph for the McCoys.

BIBLIOGRAPHY

Bolton, Robert. *A History of the County of Westchester from its First Settlement to the Present Time.* 2 vols. New York: Alexander S. Gould, 1848.

————. *The History of Several Towns, Manors and Patents in the County of Westchester.* Edited by C. W. Bolton. 3rd ed. 2 vols. New York: J. Cass, 1905.

Carmer, Bertram H. *Silver Anniversary: Mount Pleasant Bank and Trust Company.* Pleasantville, New York: privately published, 1929.

Clyne, Patricia Edwards. *Hudson Valley Faces and Places.* New York: The Overlook Press, 2005.

Donovan, Daniel, and Carolyn Casey. *A Century of Education; Pleasantville 1826–1930.* Pleasantville, New York: Higham Press, 1997.

French, Alvah P. *History of Westchester County New York.* 5 vols. New York: Lewis Historical Publishing Company, 1925.

Galusha, Diane. *Liquid Assets: A History of New York City's Water System.* Fleischmanns, New York: Purple Mountain Press, 1999.

Horne, Philip Field. *Mount Pleasant: The History of a New York Suburb and Its People.* Hawthorne, New York: privately published, 1971.

Hufeland, Otto. *Westchester County During the American Revolution 1775–1783.* White Plains, New York: Westchester County Historical Society, 1926.

Lederer, Richard M. Jr. *The Place Names of Westchester County: A Dictionary of Origins and Historical Meanings.* Harrison, New York: Harbor Hill Books, 1978.

Rockefeller, Nelson A. *Public Papers of Governor Nelson A. Rockefeller, Fifty-Third Governor of the State of New York, 1959–.* Albany, New York: privately published, 1966.

Scharf, J. Thomas. *History of Westchester County, New York, including Morrisania, Kings Bridge, and West Farms, which have been annexed to New York City.* 2 vols. Philadelphia: L. E. Preston and Company, 1886.

Souvenir Book of Pleasantville. Pleasantville, New York: privately published, 1896.

Struble, Mildred E. *Town of Mount Pleasant 1788–1988.* Mount Pleasant, New York: privately published, 1988.

Swanson, Susan Cochran, and Elizabeth Green Fuller. *Westchester County, A Pictorial History.* Norfolk, Virginia: Donning Publishers, 1982.

ACROSS AMERICA, PEOPLE ARE DISCOVERING
SOMETHING WONDERFUL. THEIR HERITAGE.

Arcadia Publishing is the leading local history publisher in the United States. With more than 3,000 titles in print and hundreds of new titles released every year, Arcadia has extensive specialized experience chronicling the history of communities and celebrating America's hidden stories, bringing to life the people, places, and events from the past. To discover the history of other communities across the nation, please visit:

www.arcadiapublishing.com

Customized search tools allow you to find regional history books about the town where you grew up, the cities where your friends and family live, the town where your parents met, or even that retirement spot you've been dreaming about.